IMAGES
of America

TICONDEROGA

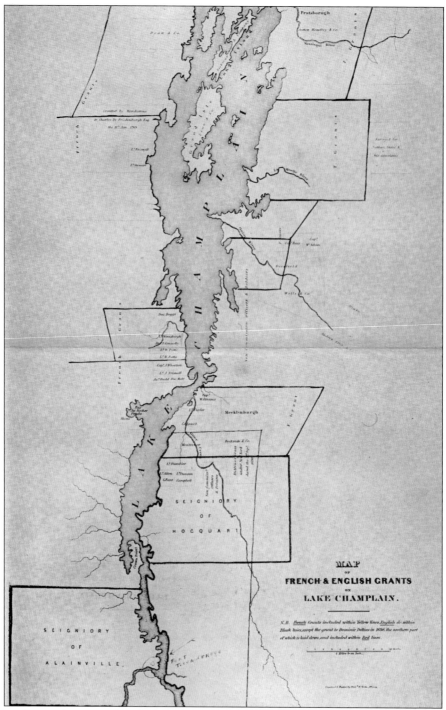

A MAP. Pictured is an undated map of the French and English land grants. (Courtesy of the Provoncha collection.)

ON THE COVER: LOWER FALLS. Local photographer Mason Smith took this photograph of the lower falls around 1950. Today, it is in a collection owned by the Ticonderoga Heritage Museum.

IMAGES
of America

TICONDEROGA

Fred V. Provoncha

ARCADIA
PUBLISHING

Copyright © 2013 by Fred V. Provoncha
ISBN 978-0-7385-9909-0

Published by Arcadia Publishing
Charleston, South Carolina

Printed in the United States of America

Library of Congress Control Number: 2012951695

For all general information, please contact Arcadia Publishing:
Telephone 843-853-2070
Fax 843-853-0044
E-mail sales@arcadiapublishing.com
For customer service and orders:
Toll-Free 1-888-313-2665

Visit us on the Internet at www.arcadiapublishing.com

*This book is dedicated to the memory of
Edith Lovina Brown Saunders and her devoted husband,
Claude. She taught in the Ticonderoga school system most of
her life and helped many of us learn how to become people.*

CONTENTS

ACKNOWLEDGMENTS

In various settings, I have picked through the memories of folks who have grown up in Ticonderoga. Too numerous to mention all, I'll note with thanks the help of Steve Boyce of the Ticonderoga Heritage Museum and Bill Trombley and Perry O'Neil of the same institution, without whom this book could not have been written. Thanks also go to Mark Wright, who created a wonderful Web page outlining much of the history of Ticonderoga that focuses on railroads, and Denise Huestis, who wrote a book about the industrial history of the town. I also wish to thank the Church of the Cross in Ticonderoga for allowing me to use an old photograph of the church and the Mount Defiance Masonic Lodge for the use of some old pictures, as well. Most non-postcard photographs are used with permission from the Ticonderoga Heritage Museum, and postcards are from my own collection unless otherwise noted.

INTRODUCTION

Ticonderoga is a mill town at its heart. About 10 million years ago, this part of the bottom of a great salt sea began to rise. Somewhere miles down, a magna chamber began to push the crust up. Over time, this created New York's Adirondack Mountains. As the land rose (and rises still), it created a 220-foot drop from today's Lake George to today's Lake Champlain, which is about the same drop as Niagara Falls but over 1.5-mile span.

Originally, Native Americans called this place Ticonderoga or something similar, and the name perhaps translates to "place between the waters" or "place where the waters meet." To the Haudenosaunee (the Iroquois), this was part of the Eastern Gate of the Great Longhouse, defended by the Kanien'kehá:ka, (the Mohawks). Here, in 1609, Samuel de Champlain, the Father of New France, and a small group of northern warriors attacked and defeated a larger group of Mohawks. While this guaranteed France the friendship of the Canadian natives, it also earned New France the undying enmity of many of the Iroquois. The first European settlement at Ticonderoga was the French fort called Carillon in the Seigneurie of Alainville by Michel-Alain Chartier de Lotbinière, the Marquis de Lotbinière. Construction of the fort started in 1755. Following the English capture of the fort in 1759, it was renamed Ticonderoga, and the French burned their villages, blew up their forts, and retreated north. After the Treaty of Paris in 1763 ended what became called the Old French War, the king granted land in Ticonderoga to several of his soldiers, providing the basis for today's Ticonderoga deeds. Since many of those soldiers never occupied the grants, local ownership of all the land was not completed until about 1870. Today's Ticonderoga became a town in the state of New York in 1804 and was set apart from the old town of Crown Point. Ticonderoga quickly became the industrial center of the region; however, in those days, the settlement was called Alexandria after it largest landowner, Alexander Ellice. Hamlets formed in places located in the lower village, like Weedsville, Streetroad, Eagle Lake, Chilson, and South Ticonderoga or Tuffertown. No work of this kind could tell the whole story of this town. The pictures, places, and people herein are representative of what Ticonderoga is and was, and we who live here are writing the story of what it will become.

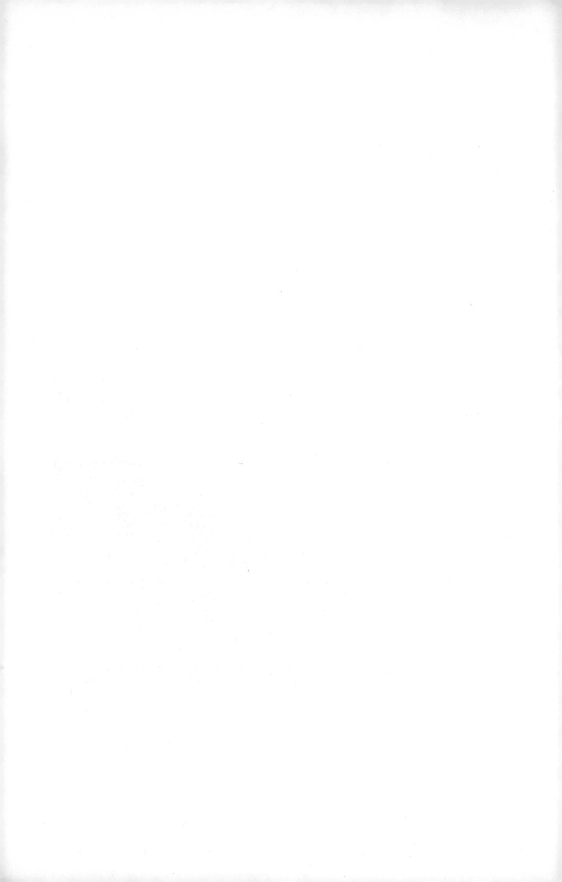

One

THE WATERS

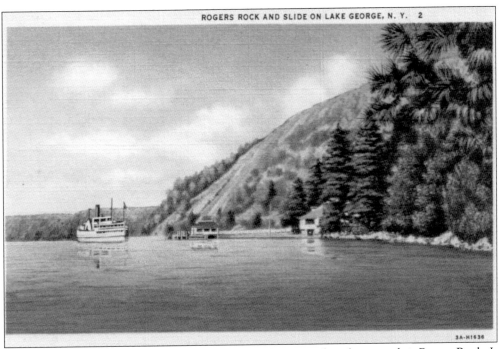

ROGERS ROCK AND SLIDE ON LAKE GEORGE, N. Y. 2

3A-H1636

ROGERS ROCK. Starting on the north side of Lake George and working north is Rogers Rock. It was here that Col. Robert Rogers, during a winter fight with the French in the French and Indian War, saved his men by pretending to have jumped or slid down onto the lake. After seeing what looked like their remains on the frozen lake bed, the Indians carefully climbed down, only to see Rogers's men waving to them from the top. Often seen today are climbers inching their way up the east face, locally called "the slide," and divers descending into the crystal-clear deep waters. In the early days of the town, an observatory was built on the summit. Long ago destroyed by the weather, only a few iron bolts remain.

ROGER'S ROCK HOTEL AND HEART BAY, SHOWING WRECK OF STEAMER TICONDEROGA, LAKE GEORGE, N.

de in Germany for H. R. Hulett, Ticonderoga, N.Y. No. 29 *I am now staying at this hotel where is often find place*

HEARTS BAY. Hearts Bay is one of the more beautiful bays on Lake George. Its shape and Rogers Rock protect it from the wind. Its clear shallow water and sandy bottom offer an idyllic place for camping and swimming. On the north side is the dry dock for many of the lake's excursion boats. The Windmill house on its southern point is a place often pointed out to visitors. Here is one of the Indian trails leading up over Cooks Mountain to South Ticonderoga. While its old name reflected the person who owned much of the land here, its shape (from the proper vantage point) gave it the name most commonly used today, as above.

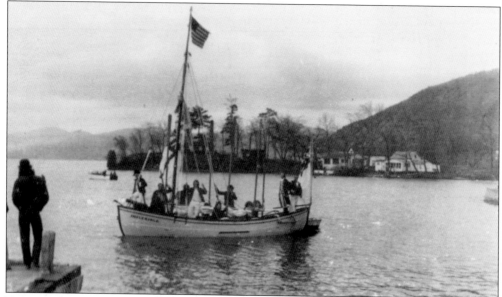

BALDWIN DOCK. Here is the northern terminus for passengers bound for Ticonderoga or points accessible from Lake Champlain. In the early days, Capt. William Baldwin's stagecoach would take travelers to Ticonderoga's hotels or to Lake Champlain; however, in later years, a train took people to those destinations. Pictured in 1976 is the replica HMS *Inflexible* approaching the dock after firing a few shots over the bow of the MV *Ticonderoga* with Black Point in the background. (Courtesy of Perry O'Neil.)

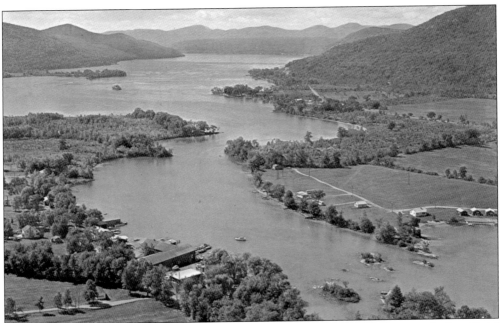

LAKE GEORGE LOOKING SOUTH. The small Islands on the right of the picture mark the official end of the lake; one island is named Diane's Rock with a plaque on it honoring the woman's swim of the 32-mile length of Lake George. Note the Black Point peninsula extending out into the lake from the left and Prisoners Island just before that. The story is that the English housed some captured French on the island, not realizing how shallow the water was, and in the night, the prisoners, who were familiar with the surroundings, simply waded away.

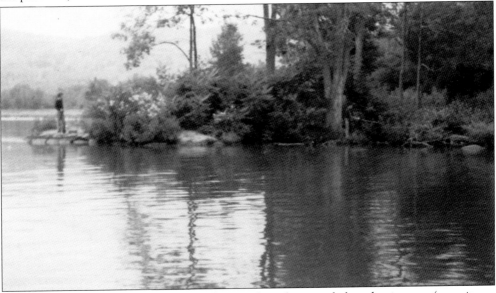

STILL WATER. Just inside Lake George's last northern bay is a sheltered quiet spot (or so it was when this picture was taken). Since that day, the State of New York has built a boat launch directly across from this spot, and several homes have been erected near where the young man is fishing. Once this bay was filled with yellow perch, bass, chain pickerel, and the ubiquitous bullhead. Today, only the bullhead remains, and the stocking program resupplies the bass.

VULTURE HILL. This is a view of the small hill across from a camp on Lake George, just north of the last picture. Several turkey vultures circle the top of this hill all summer long. From their high vantage point, they can scan both Lakes George and Champlain, swooping in on any prey they observe. This bay is one of several places that a boat speed limit is in effect (five miles an hour, no wake). The water here is shallow, and if the dam holding the lake back were to be opened, only a small stream would meander through a very large mud flat.

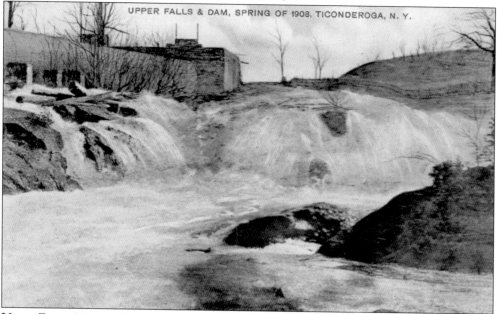

UPPER FALLS. Moving down from Vulture Hill, water passes into the LaChute River, under the Alexandria Avenue bridge and the old train trestle, and eventually pours over the A dam. The B dam's pond and mill sit above the falls in this picture. Here, when the water is lower and slower, the upper falls' swimming hole, known locally as the Bass Hole, can be found. With the mills long gone, campers and fishermen often frequent this site. (Courtesy of William Trombley.)

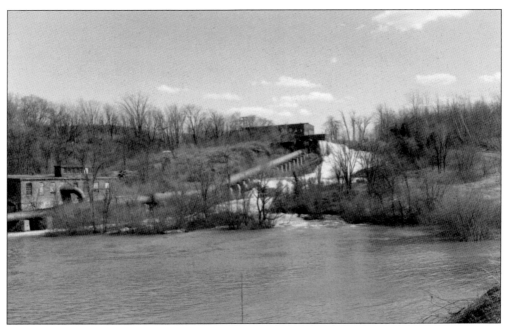

LORD HOWE LAKE. The C millpond pools the water from the upper falls. It is sometimes referred to by the name of the British lord who was killed near that spot. (Courtesy of Perry O'Neil.)

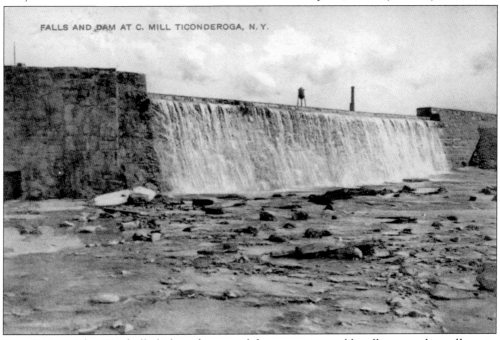

FALLS AND DAM AT C. MILL TICONDEROGA, N.Y.

THE C DAM. The Weedville kids and many of their parents would walk across the spillway to get to school or "Downstreet." Sadly, before the dam was lowered in the 1970s, more than one person lost his or her life in that pond. This dam was constructed to provide a reservoir of pure Lake George water to the mills at the lower falls, unmixed with the muddier Trout Brook water entering the stream just below the dam. Large pipes, called penstocks, brought the water to the lower mills. (Courtesy of William Trombley.)

THE RACEWAY. The C dam was built around an island, allowing the water to take two courses north. This flow (the left one) was swift and shallow, a great place to catch crayfish. The other flow was slow and deep, and a bosun's chair allowed mill workers to travel from either. Also a stairway down from the dam allowed anyone access to the island, and a trail led down the island to the bosun's chair tower. (Courtesy of Perry O'Neil.)

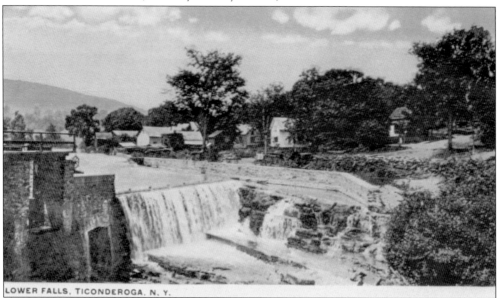

LOWER FALLS, TICONDEROGA, N. Y.

THE D DAM. Though the picture says "lower falls," it should read "middle falls." These falls were enhanced to create another millpond, which in part floated logs to Silas Moore's sawmill just below the dam at the Exchange/Montcalm Street Bridge. While the sawmill is long gone, the boards made there are still a part of many Ticonderoga buildings, including the author's house, which was built as a grain and wood store. At one time, there was a walkway that allowed crossing the stream. (Courtesy of William Trombley.)

14

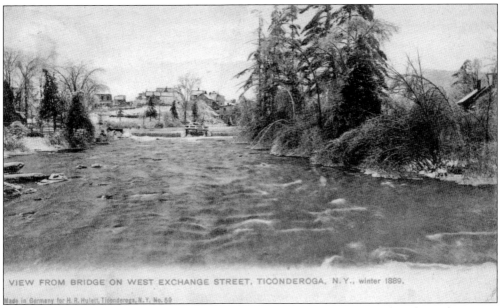

VIEW FROM BRIDGE ON WEST EXCHANGE STREET, TICONDEROGA, N.Y., winter 1889.

Made in Germany for H. R. Hulett, Ticonderoga, N.Y. No. 60

ANOTHER VIEW. Looking south (upstream) from the Montcalm Street Bridge, the D dam water churns its way down to Lake Champlain and then continues its trip to the sea. Today's LaChute River is about half as wide as it once was. As the demands on the water supply increased, the mills narrowed the stream to increase the force of the water. Stores are now located where some of the water would have been in this photograph.

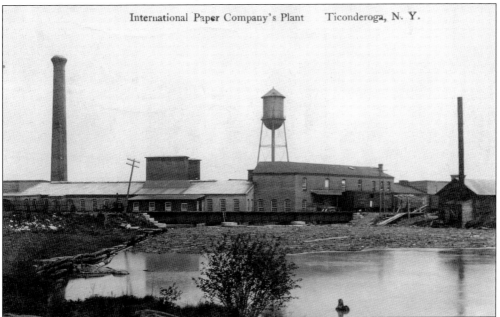

International Paper Company's Plant Ticonderoga, N. Y.

THE TAMED RIVER. In the end, International Paper manipulated the river to meet its needs. Once a large unnamed island was in the center of the flow, but then the island disappeared when the river's southern branch, Spencer Creek, was fed into a pipe and covered over. Many streams that fed the river disappeared, and the several dams slowed the cascades. Here, the river sits quiet and peaceful.

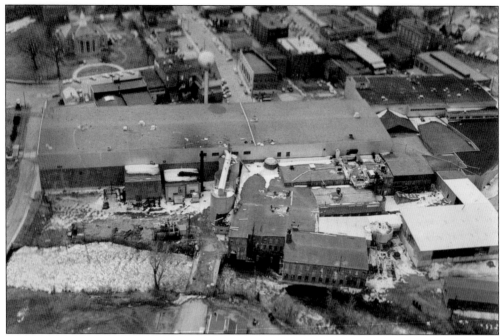

The Frasier Bridge. Once the Main Street Bridge, this connected the northeastern part of the town (Mount Hope area) to the main lower village. About 1960, when the No. 7 paper machine was installed in the Island Mill (center of this picture), access to this bridge was severely restricted, and most of North Main Street (then called Champlain Avenue) was demolished. A new road, Tower Avenue, was built to allow north-south traffic. (Courtesy of Perry O'Neil.)

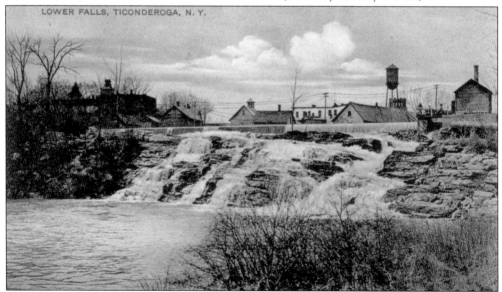

Lower Falls. Here is the E dam. The Richards dam, not shown here, sits between the D and E dams. This dam exists just to control erosion at the top of the lower falls. Before the early 1970s, there was a large shallow pool behind this dam, but most of it has now been filled in. The lower falls is Ticonderoga's showcase. Surrounded by the Bicentennial Park, it is the place for fishermen, canoeists, concerts, weddings, and much more.

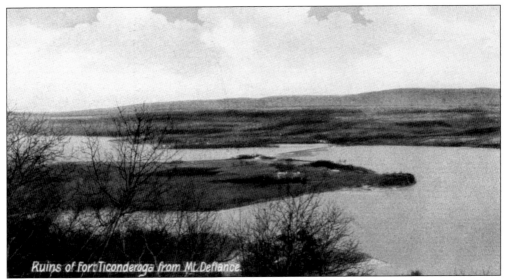

Ruins of Fort Ticonderoga from Mt. Defiance

THE LAKES. Here, the outflow from Lake George, falling 220 feet over about three miles, joins the Lake Champlain waters on their long journey north to the sea. When this picture was taken, old Fort Ticonderoga was still in ruins, and a train bridge connected New York and Vermont at the site of today's Fort Ticonderoga Ferry. The state regularly dredged the creek to keep the passageway open to boats and barges.

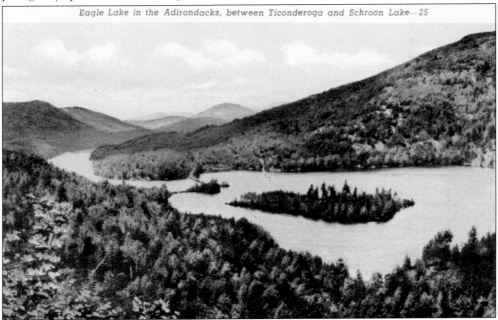

Eagle Lake in the Adirondacks, between Ticonderoga and Schroon Lake—25

EAGLE LAKE. On the western border of Ticonderoga, the Eagle Lake settlement has mostly been seasonal. It is said the Native Americans settled here to hunt and fish, but that as the Europeans moved in, they quietly moved out. Occasional signs of their presence turn up from time to time. Here, in the deep cold lake, ice fishing is a favorite sport, and many cabins dot its shores. At one time, a large camp was established on one of its islands, but most traces of that are now gone. In the early days there, a floating bridge connected the Ticonderoga Road to the Schroon Lake road to the west, near where today's causeway crosses the lake.

THE FLOATING BRIDGE. Looking east from the fort's peninsula is the floating drawbridge in the open position. In the active days of Fort Ticonderoga, a floating bridge also connected the fort to Mount Independence in today's Vermont. When the fort commander Arthur St. Clair was retreating from the British attack, he used that bridge to escape. Had he been able to demolish the bridge in time, his retreat would have been much safer. Trains crossed this bridge from Larrabee's point to connect to the Addison Railroad in New York. Most made it, but some did not.

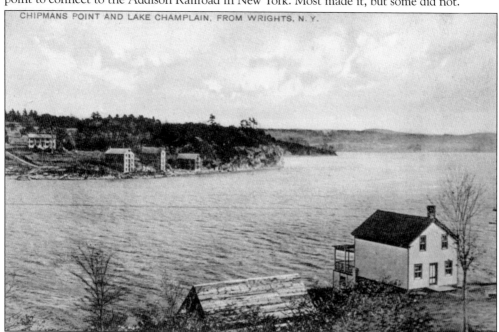

CHIPMANS POINT AND LAKE CHAMPLAIN, FROM WRIGHTS, N. Y.

WRIGHT'S FERRY. Historically, there were two ferries in town; shown here is the building housing Wright's three-minute ferry to Vermont, which shut down many years ago. The other (Fort Ticonderoga Ferry) is near the floating bridge. After the sudden closing of the Crown Point Bridge a few years ago, the engineers looked into reopening this one but decided not to. The approach from the New York side closely intersects the train tracks and has a very steep angle. It also sits a fair distance from the main road.

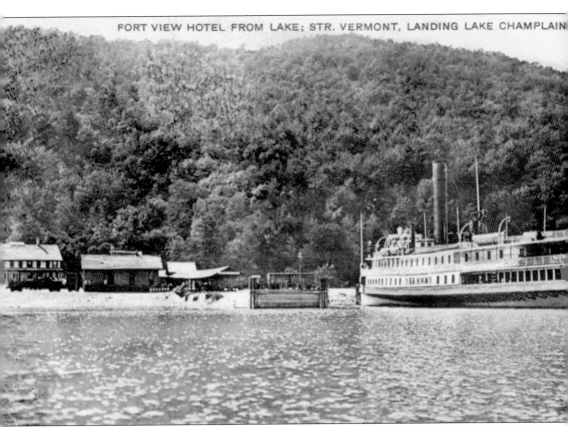

PORT MARSHAL. Here is another view of the Fort View Hotel with a steamer in dock. The hill behind the hotel is called Mount Defiance. For a while, there was a train trestle that went way out into the lake here. While many of the pilings are still in the lake, winter ice made short work of the trestle. This was the main intersection for travel in Ticonderoga. The various stages met the boats and trains here, allowing passenger traffic from the north and south to transit through Ticonderoga to Lake George and points west.

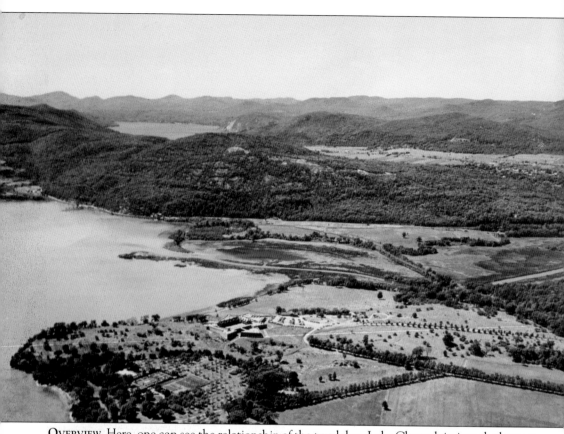

OVERVIEW. Here, one can see the relationship of the two lakes. Lake Champlain is at the bottom, with the fort's peninsula just above that; Mount Defiance is in the middle; and Lake George is near the top, with a bit of the LaChute River center right. Note the train trestle crossing LaChute River. What is not so obvious is the 220-foot height difference.

Two

THE FORTS

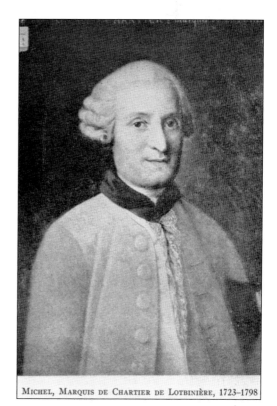

THE FORT. Construction was begun on Fort Carillon in 1755 by the Marquis de Lotbinière (pictured). The fort grew quickly, and within three years, the French, under the able leadership of the Marquis de Montcalm, turned back a serious British attack. However, the French were not long to enjoy their victory. A year later, the fort fell to an overwhelming British army, and within a year, Gen. James Wolfe beat de Montcalm on the Plains of Abraham; both men died of wounds received in the battle. New France was no more, Carillon became Ticonderoga, and Pointe à la Chevelure became Crown Point. (Courtesy of the Provoncha collection.)

MICHEL, MARQUIS DE CHARTIER DE LOTBINIÈRE, 1723–1798

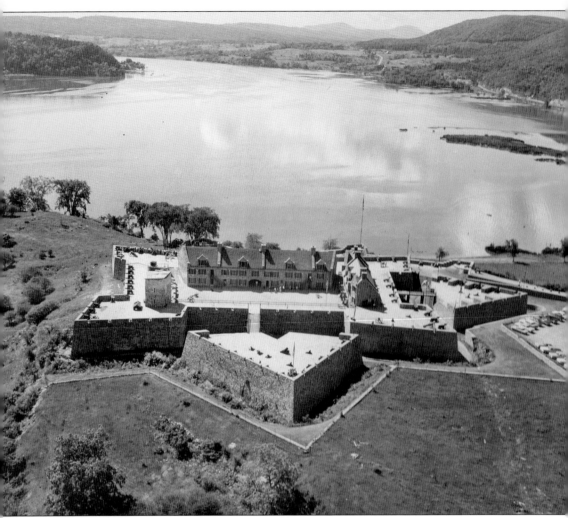

THE STAR FORT. Pictured is the restored fort. Called sometimes the "Great Stone Fortress" or "America's Fort," Fort Ticonderoga sits here framed by Lake Champlain (looking south), Mount Defiance on the west (right), and Mount Independence on the east (left). While this is a great spot for historians, it is also a great spot for fishermen. Several large streams enter the lake here. (Courtesy of William Trombley.)

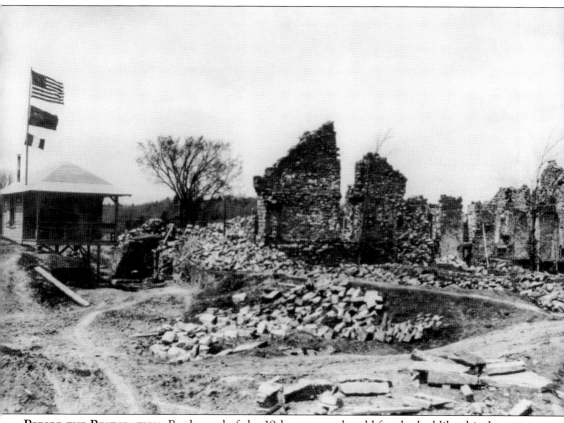

BEFORE THE RESTORATION. By the end of the 19th century, the old fort looked like this. It was a hallowed spot, and yet cows grazed here. Farmers and townsfolk brought their wagons here for a plentiful supply of dressed stone for foundations for houses and barns. Fort Ticonderoga was slowly fading away into history; however, the Pell family acquired control of the area, and ever so slowly, the old fort came back to life. (Courtesy of William Trombley.)

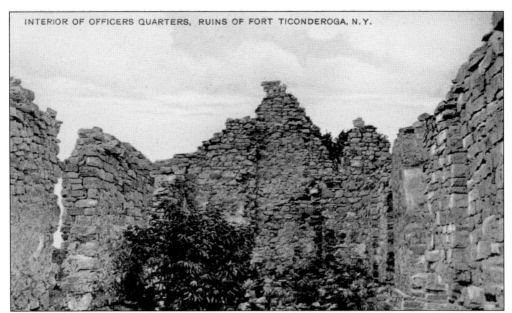

INTERIOR OF OFFICERS QUARTERS, RUINS OF FORT TICONDEROGA, N.Y.

THE RUINS. And here is another view. The most intact part of the fort was the Officers' Quarters, shown here. Today, one can visit the restored rooms. Reenactors help visitors experience almost every aspect of life in the 1700s. In the newly constructed Deborah Clarke Mars Education Center Building, lines in the floor indicate where the original walls once stood.

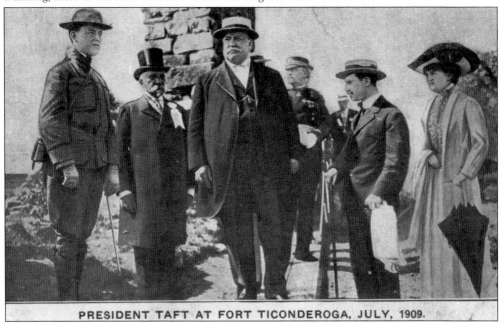

PRESIDENT TAFT AT FORT TICONDEROGA, JULY, 1909.

THE PRESIDENT IN TOWN. In 1909, about 300 years after Samuel de Champlain fought the Mohawks here, the US president William H. Taft came to town to attend the dedication of the new Fort Ticonderoga Museum. The founders of the museum were Stephen and Sarah Pell. Standing in the ruins of Old Fort Ticonderoga, Taft perhaps surveys how far people have come from that long-distant day. In the early days of the town, several of the founding fathers came to Ticonderoga to reflect on the events that happened here.

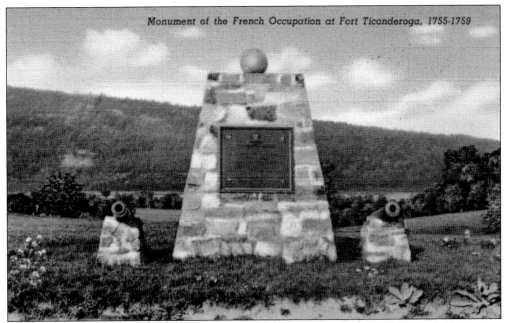

Monument of the French Occupation at Fort Ticonderoga, 1755-1759

THE OTHER FOUNDING FATHERS. The French knew, as did the Iroquois before them, that this was the control point for the country. So it was here that they built their anchor fort and a small farming community. They built a sawmill at the lower falls and used the lumber in part to build the fort. Alainville-Lotbinière named the place and expected to one day be lord of the manor here. He envisioned a prosperous community with mills on the river and peaceful farms throughout the valley, all protected by his fort—which never came to be.

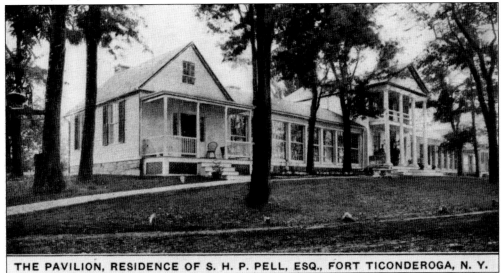

THE PAVILION, RESIDENCE OF S. H. P. PELL, ESQ., FORT TICONDEROGA, N. Y.

THE PAVILION. Alainville-Lotbinière's hopes for the area never happened, because the British won the war and Fort Carillon became Fort Ticonderoga. Time marched on, and the fort changed hands back and forth, finally falling into decay. But then came the Pell family. First upon the site, they built a lovely summerhouse, erected by William Ferris Pell. After a family tragedy, it was converted into a hotel in 1839 and lasted until the end of the century. It still sits there today, next to the restored King's Gardens.

25

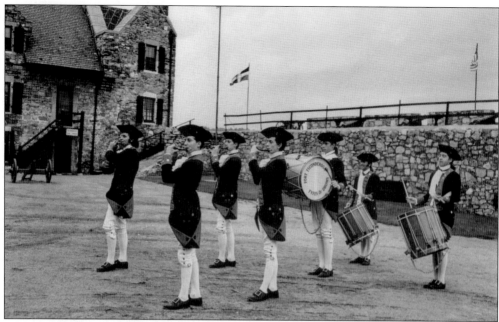

FIFES AND DRUMS. Pictured is the Fort Ticonderoga Fife and Drum Corps. The restored fort today reenacts the events of 250 years ago. Here, one can peek into those long-ago days and hear the fifes and drums once again. The lake is full of the artifacts of those olden days, but note that the state frowns on souvenir collectors. Generations of Ticonderoga's children joined the corps. They learned near-forgotten skills, and the best of them traveled around the country and the world performing.

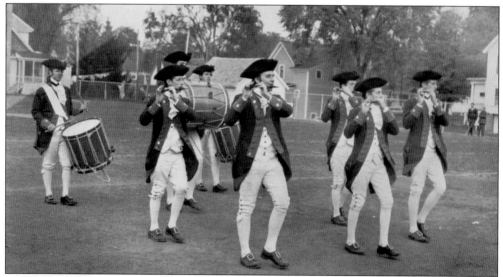

MORE FIFERS. Here, members of the corps are pictured on the high school's football field. All of this was a very normal and natural part of life growing up in Ticonderoga. Many of the local youth were in the corps, and many public functions included some activity from the fort. Every parade in town for almost a century had the sound of fifes and drums. These young folks move exactly in step, following almost unseen commands of their leaders. Note also that they have played before the crowned heads of Europe.

THE REENACTORS. Here are some of the many folks prepared to bring the 1700s back to life. After 100 or so years of research, Fort Ticonderoga knows the story, and reenactors are skilled in sharing that story with the public. It is always fun to be sitting in a restaurant when a reenactor comes in to dine—some stay in character, but most just blend in with the crowd.

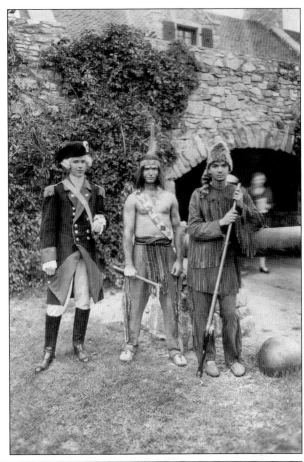

THE SPIRIT OF TICONDEROGA. In 1955, a television program was produced from the play *The Spirit of Ticonderoga*. Pictured is the cast of the show appearing in Ticonderoga in a publicity shot at Fort Ticonderoga. In 1953, a major motion picture, called *Fort Ti*, premiered in Ticonderoga in 3-D at the old State Theater. While it was not a huge success, the movie did achieve a sort of cult following, and to say the least, the special effects were stunning for its day. (Courtesy of Perry O'Neil.)

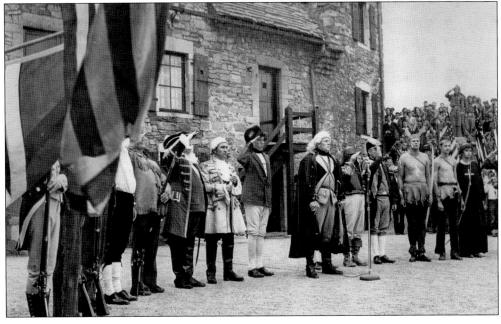

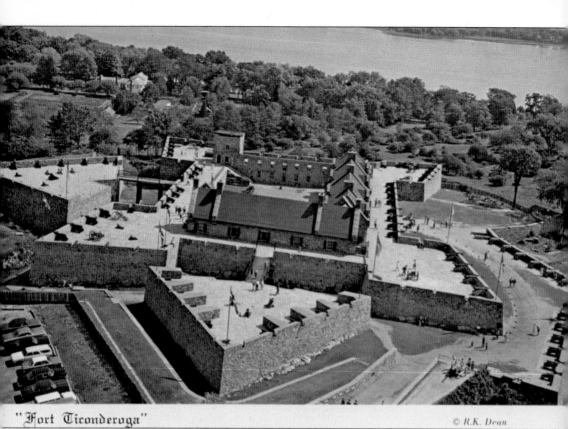

"Fort Ticonderoga" © *R.K. Dean*

UP CLOSE. Here, the people demonstrate the size of the structure. Also note Lake Champlain and Vermont in the background. One can stand here and travel in time. Visiting Fort Ticonderoga should be on everyone's bucket list.

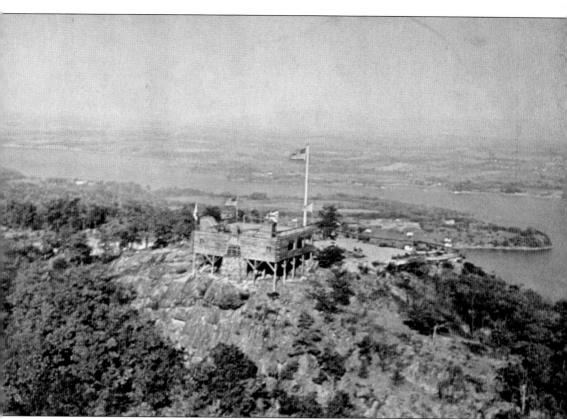

Mount Defiance. Not every community has a mountain in the middle, but Ticonderoga does. While American general Arthur St. Clair slept in his impregnable Fort Ticonderoga, British general John Burgoyne cut a road partway up Mount Defiance on July 5, 1777, and posted two cannons. Awakening to see the British in a commanding position, the Americans fled, abandoning Forts Ticonderoga and the fortifications across the lake called Mount Independence; the American retreat ended at a place called Saratoga (Stillwater).

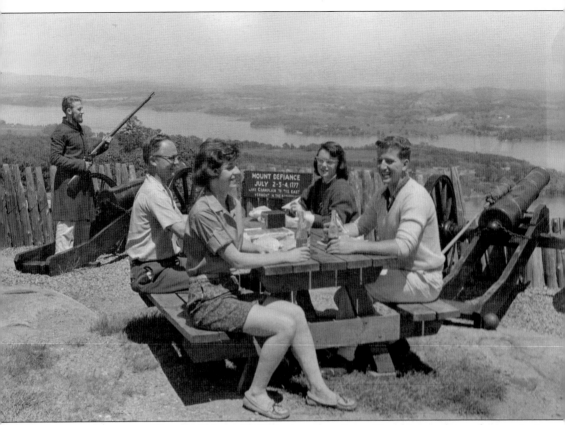

MOUNT DEFIANCE. The top of Mount Defiance later transformed into a great place to have a picnic. Where this table stood in the 1950s, there is a blockhouse today. On its side is a plaque honoring one of Ticonderoga's favorite sons, Anthony "Tony" Morette, who managed the mountain in his twice-daily runs up and down the hill for many years until his untimely death in 2009. The old metal survey or benchmark markers are visible on top of the mountain.

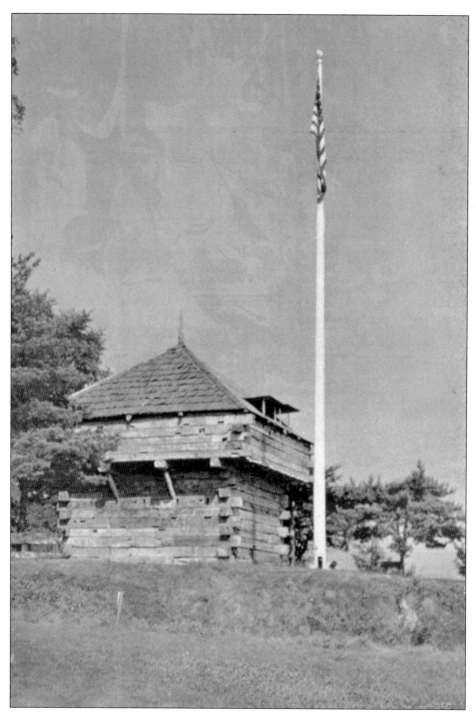

MOUNT HOPE. It is a good name for a mountain, or in this case, a low hill. It, as well as Mount Defiance, was not actually a fort, but both were, and still are, dependencies of Fort Ticonderoga. At Mount Hope, troops were billeted, along with a fairly large native contingent. The structure pictured used to be filled with artifacts. A long, low building held countless treasures acquired from the surrounding area. Today, the gate to the area is locked.

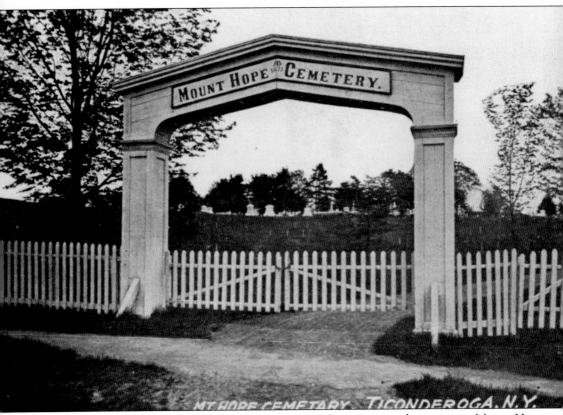

MOUNT HOPE CEMETERY. One of Ticonderoga's nondenominational cemeteries, Mount Hope Cemetery contains many of the movers and shakers of Ticonderoga's historic past. Here, there is a bench erected to the memory of Roger Dechame. He and his wife, Stephanie Sara Pell Dechame, are interred in the cemetery together. He hit the beaches at Normandy and, soon after, married the heir to the Fort Ticonderoga holdings. (Courtesy of William Trombley.)

Three

THE MILLS

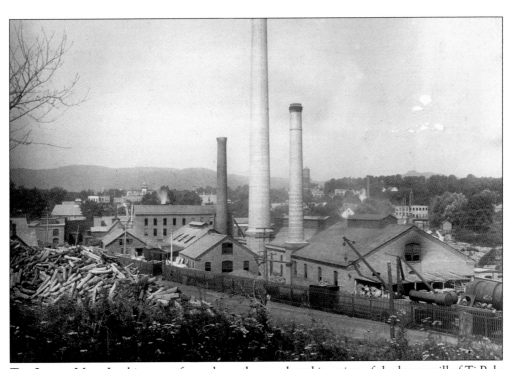

THE LOWER MILL. Looking west from above the wood yard is a view of the lower mill of Ti Pulp and Paper. It looks to be about 1900. If this were 100 years earlier, one would see a large open boat basin, but over the mill's existence, that basin was filled in, and more buildings were erected on the new land. Ti Pulp and Paper was the main economic engine in Ticonderoga in its day. This mill and the Island Mill became the backbone of International Paper's Ticonderoga mill No. 38.

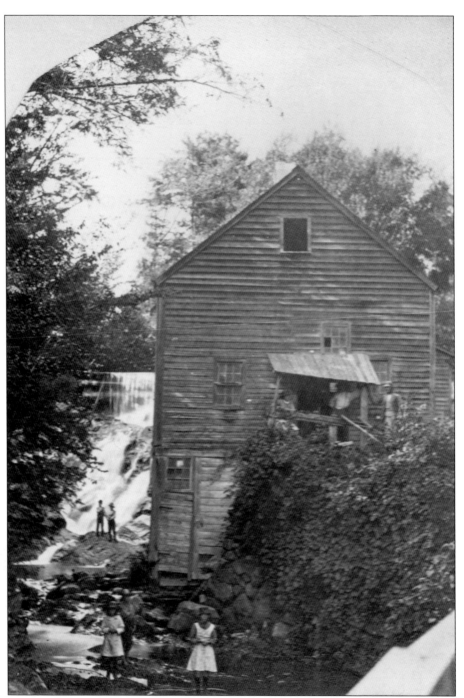

UNKNOWN MILL AT THE UPPER FALLS. This stereoview of an old mill at the upper falls is undated but is most likely from the 1890s. Like the lower falls, there was an island area between the flows, long ago incorporated into the various mills. Note the children posing on the rocks. What a big event it must have been for them to have their picture taken. Years later, the mills almost completely covered this area. Today, they are returning to a more natural look, but the dam installed here at the upper falls keeps Lake George eight feet higher than it would otherwise be.

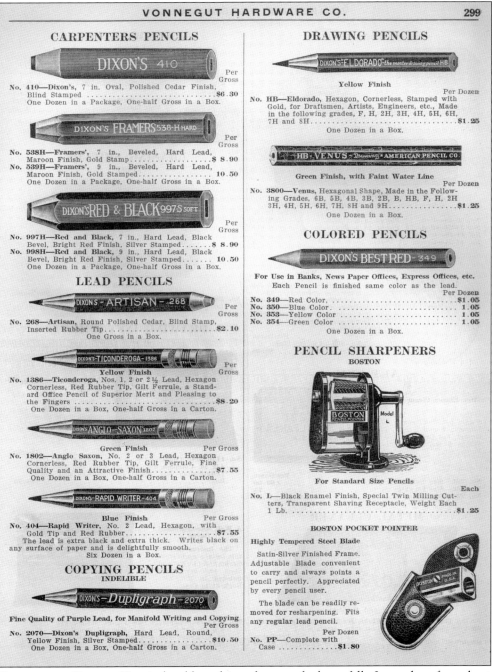

CARPENTERS PENCILS

DIXON'S 410

Per Gross

No. 410—Dixon's, 7 in. Oval, Polished Cedar Finish,
Blind Stamped$6.30
One Dozen in a Package, One-half Gross in a Box.

DIXON'S FRAMERS 538-H HARD

Per Gross

No. 538H—Framers', 7 in., Beveled, Hard Lead,
Maroon Finish, Gold Stamp...................$ 8.90
No. 539H—Framers', 9 in., Beveled, Hard Lead,
Maroon Finish, Gold Stamped.................10.50
One Dozen in a Package, One-half Gross in a Box.

DIXON'S RED & BLACK 997-S SOFT

Per Gross

No. 997H—Red and Black, 7 in., Hard Lead, Black
Bevel, Bright Red Finish, Silver Stamped......$ 8.90
No. 998H—Red and Black, 9 in., Hard Lead, Black
Bevel, Bright Red Finish, Silver Stamped......10.50
One Dozen in a Package, One-half Gross in a Box.

LEAD PENCILS

DIXON'S - ARTISAN - 268

Per Gross

No. 268—Artisan, Round Polished Cedar, Blind Stamp,
Inserted Rubber Tip...........................$2.10
One Gross in a Box.

DIXON'S TICONDEROGA - 1386

Yellow Finish

Per Gross

No. 1386—Ticonderoga, Nos. 1, 2 or 2½ Lead, Hexagon
Cornerless, Red Rubber Tip, Gilt Ferrule, a Stand-
ard Office Pencil of Superior Merit and Pleasing to
the Fingers$8.20
One Dozen in a Box, One-half Gross in a Carton.

DIXON'S ANGLO - SAXON 1802

Green Finish Per Gross

No. 1802—Anglo Saxon, No. 2 or 3 Lead, Hexagon
Cornerless, Red Rubber Tip, Gilt Ferrule, Fine
Quality and an Attractive Finish..............$7.55
One Dozen in a Box, One-half Gross in a Carton.

DIXON'S RAPID WRITER - 404

Blue Finish Per Gross

No. 404—Rapid Writer, No. 2 Lead, Hexagon, with
Gold Tip and Red Rubber.......................$7.55
The lead is extra black and extra thick. Writes black on
any surface of paper and is delightfully smooth.
Six Dozen in a Box.

COPYING PENCILS
INDELIBLE

DIXON'S - Dupligraph - 2070

Fine Quality of Purple Lead, for Manifold Writing and Copying
Per Gross

No. 2070—Dixon's Dupligraph, Hard Lead, Round,
Yellow Finish, Silver Stamped..................$10.50
One Dozen in a Box, One-half Gross in a Carton.

DRAWING PENCILS

DIXON'S "EL DORADO" the master drawing pencil HB

Yellow Finish

Per Dozen

No. HB—Eldorado, Hexagon, Cornerless, Stamped with
Gold, for Draftsmen, Artists, Engineers, etc., Made
in the following grades, F, H, 2H, 3H, 4H, 5H, 6H,
7H and 8H....................................$1.25
One Dozen in a Box.

HB - VENUS - Drawing - AMERICAN PENCIL CO.

Green Finish, with Faint Water Line

Per Dozen

No. 3800—Venus, Hexagonal Shape, Made in the Follow-
ing Grades, 6B, 5B, 4B, 3B, 2B, B, HB, F, H, 2H,
3H, 4H, 5H, 6H, 7H, 8H and 9H...............$1.25
One Dozen in a Box.

COLORED PENCILS

DIXON'S BEST RED - 349

For Use in Banks, News Paper Offices, Express Offices, etc.
Each Pencil is finished same color as the lead.
Per Dozen

No. 349—Red Color.............................$1.05
No. 350—Blue Color1.05
No. 353—Yellow Color1.05
No. 354—Green Color1.05
One Dozen in a Box.

PENCIL SHARPENERS
BOSTON

For Standard Size Pencils
Each

No. L—Black Enamel Finish, Special Twin Milling Cut-
ters, Transparent Shaving Receptacle, Weight Each
1 Lb.$1.25

BOSTON POCKET POINTER

Highly Tempered Steel Blade

Satin-Silver Finished Frame.
Adjustable Blade convenient
to carry and always points a
pencil perfectly. Appreciated
by every pencil user.

The blade can be readily re-
moved for resharpening. Fits
any regular lead pencil.

Per Dozen

No. PP—Complete with
Case$1.80

TICONDEROGA PENCILS. Here is the old graphite refinery at the lower falls. It was there from about 1850 until it burned in 1968. Next to it was the iron mill, and together they fought the upstart paper mill on the other side of the river. Ticonderoga is full of limestone, and consequently, it also is full of very high-grade graphite. First discovered in the early 1800s, it quickly became a "cash crop" with several companies competing for the business. The eventual winner was the Joseph Dixon Crucible Company of Jersey City, New Jersey, where the Ticonderoga pencils were eventually made.

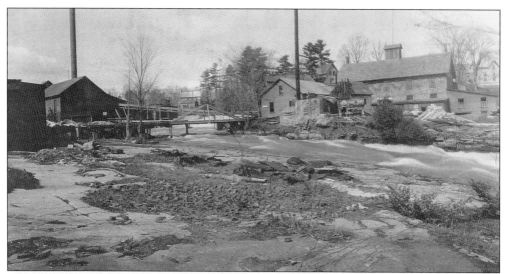

RICHARDS MILL. This early shot, taken in the 1890s, is of the Richards pulp mill and the walkway that crossed the flow near the middle of town. The only dam in Ticonderoga that has a real name is the one found here. This mill was built where the old Treadway woolen mill was once located. Sheep were once an important resource in Ticonderoga, and wool was heavily worked here. (Photograph given to the Ticonderoga Heritage Museum; courtesy of Ticonderoga Historical Society.)

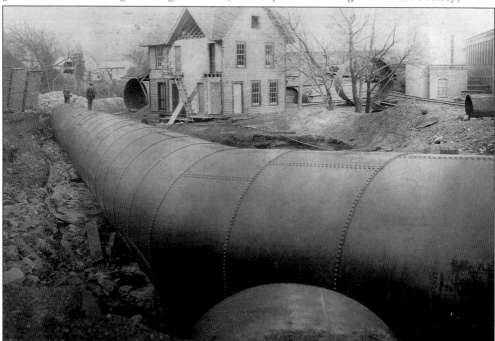

A PENSTOCK. Here is a penstock. When these were common, one could hear the water moving in the pipe while walking along on them. It was important to keep a close eye at one's feet and the randomly placed rivets. With one slip, there would be a painful 12-foot fall into either muddy rocks and water or a fast moving stream. The mills built the penstocks to carry clean Lake George water to the mills downstream. (Photograph given to the Ticonderoga Heritage Museum; courtesy of Ticonderoga Historical Society.)

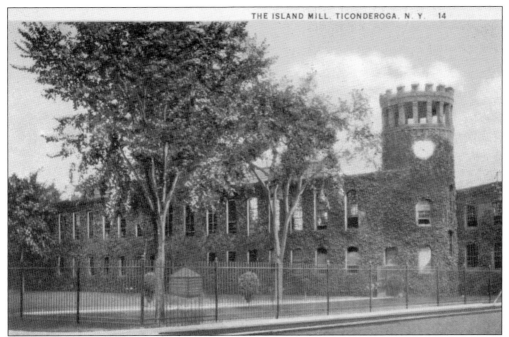

THE ISLAND MILL. The mill began in 1891 and was built on the large island that once graced the center of the village. The mill quickly became the signature building in the town. Its steam whistle and the clock tower got people's attention. By the 1950s, most people had no idea there had once been an actual island there. One walked down a slight hill into the building and never knew that one had crossed the old riverbed of Spencer Creek.

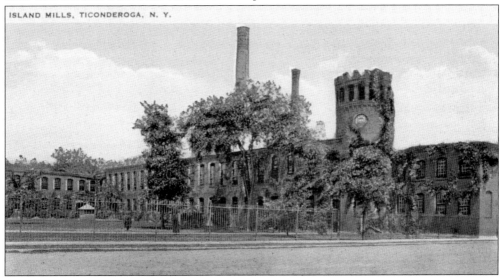

ISLAND MILLS, TICONDEROGA, N. Y.

THE CLOCK TOWER. Originally, the clock tower did not have a clock. In the mill's early days, where the clock was later located was where the name of the company was placed. If one drove down that street today, it would have to be on a bike; there is only a path through a field left there now. But in its day, this was a busy thoroughfare. Its short distance included the town's main mill, an active hotel, a popular watering hole, and a graphite mill. A few private homes and several small businesses also lined the street.

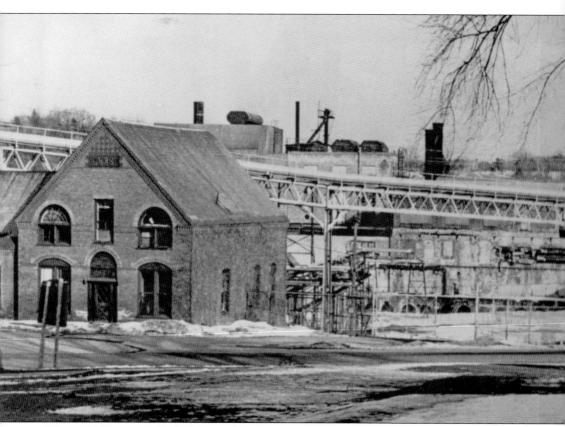

THE 1888 BUILDING. Today's Ticonderoga Heritage Museum had a very different start in life. In 1888, Clayton Harris Delano constructed it as his main office building, and in a few short years, it was expanded (adding the section on the left). A railroad ran up onto the island just behind the building, and eventually, pipes soared over it to feed the new No. 7 machine building. For a while, people called it the time office, and personnel and engineering were housed there. Clayton Harris Delano would have found it a very noisy place to work. In the back of the building is a large walk-in safe, which is empty now, but in its day, it probably held important company papers.

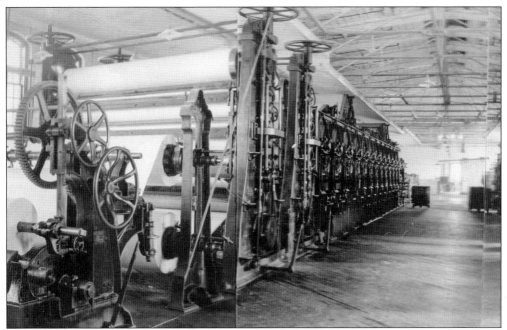

PAPER MACHINES. Probably of the No. 3 machine, this photograph actually had both Nos. 3 and 4 in it, but cropping took out the other machine. Nos. 3 and 4 were the original paper machines in the Island Mill. One of the hardest mill jobs was "break." Break was using long hooks to pull flowing paper out from between rollers, which were extremely hot and quite dangerous. Most employees vastly preferred pumping up the pulper, which was adding preprocessed pulp to the holding tank that fed the machines.

COMPANY LOGO. C.H. Delano was an important man in Ticonderoga in his day. As a young teacher, he learned how hard life could be, and he took those lessons to the grave. The company he founded became the core element in International Paper's Ticonderoga presence.

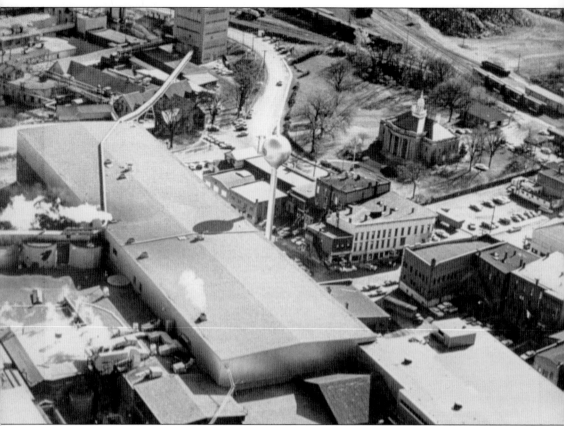

No. 7. Between the years 1960 to 1970, International Paper's mill No. 38 was mostly about No. 7. With the mill centered in the downtown area and major Route 22 going right through the town with the summer tourist traffic, the area was a mecca for local merchants. But the handwriting was on the wall. Soon a bypass was built to relieve the traffic problem, and then the mill, constrained by aging equipment and waste disposal issues, found a new home in the northern part of town. Suddenly, a place filled with people was almost empty. It did not happen overnight, but it did happen.

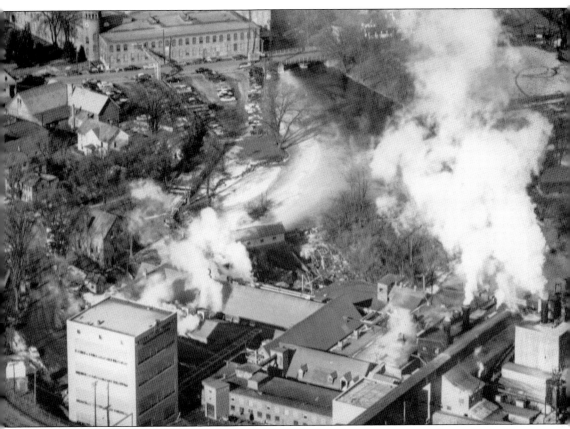

BEFORE NO. 7. Here, one can see the Island Mill just before alterations were made to add the No. 7 machine building. The river comes in almost to the 1888 Building, and a large parking lot is seen east of the buildings. The Ti Inn is sadly gone, and those homes in top left are soon to be removed. In this picture, the American Graphite Building is hidden by the smoke.

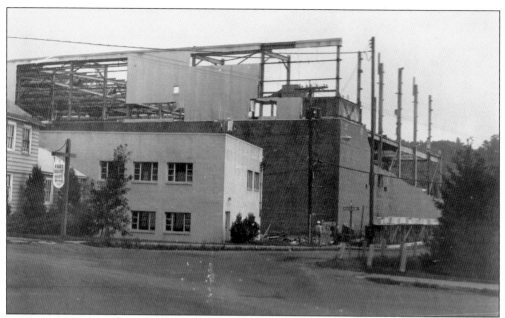

GONE. And here they are taking the No. 7 building down in the early 1970s. Note the Fort Mount Hope sign on the bottom left. It is soon to be yet another memory. But as for No. 7, life goes on. It is on its way to be reinstalled in Ticonderoga's new mill No. 10 alongside its new "cousin," the newer and bigger No. 8. (Courtesy of Perry O'Neil.)

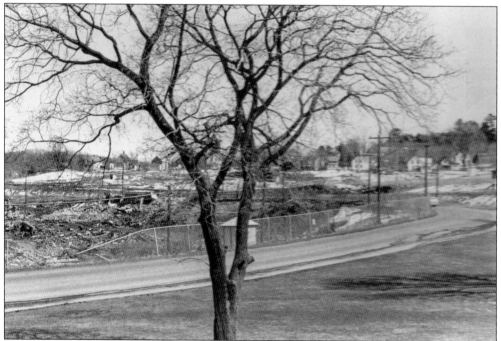

SAID AND DONE. And here is a shot of the lower mill area when all is said and done. With over 150 years of industrial use, it is now quiet. There will be some more cleanup and some grading and prep work, but the new noises one will hear here will be the sounds of children playing, runners running, strollers strolling, anglers angling, and canoers canoeing. (Courtesy of Perry O'Neil.)

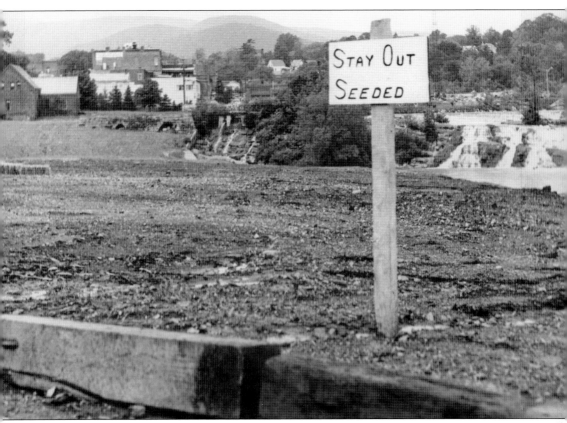

BEGINNING OF THE PARK. There is now a feeling of expectation. Mount Hope may be gone, but hope springs eternal in Ticonderoga. There is a park in the center of town; the lower falls have been reborn; the Ticonderoga Heritage Museum conjures up memories for folks. And right in the middle of that falls is a new hydro plant. On most weekends in the summer, couples are married there, and the area also plays host to fairs, carnivals, and fireworks. (Courtesy of Perry O'Neil.)

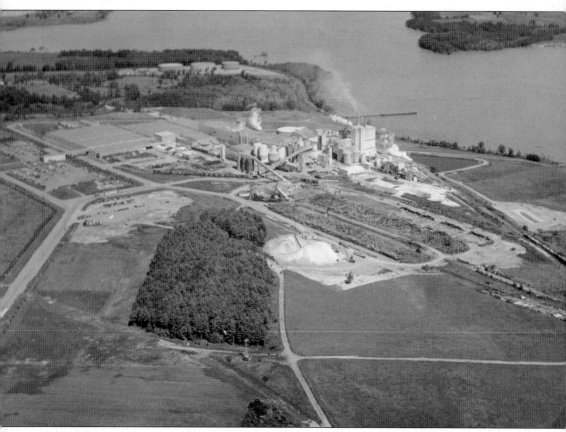

MILL NO. 10. International Paper's new mill No. 10 continues to employ citizens, to help fund community activities, and to provide quality products to its customers. International Paper's story and Ticonderoga's are interrelated, born of the same mother so to speak, and the mother is the LaChute River, endlessly falling those 220 feet, turning water wheels and turbines. The river is still producing power for the next generation of users. (Courtesy of Perry O'Neil.)

Four

DOWNSTREET

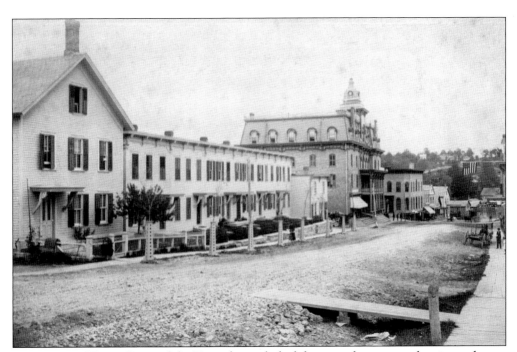

STREETSCAPE No. 1. Some of the Ticonderoga kids did not go downtown, they instead went "Downstreet." Looking North on Main Street/Champlain Avenue, Drake block is on the right, Burleigh House is on the left, and the Island Mill is not yet built in about 1880. By then, the water system was in, and fire hydrants were available. In those days, the leading lights in town thought the Mount Hope area (top of the picture) would become the place to be. Churches and homes were built there, but for some reason, that area never really took off. The town instead expanded up Lake George Avenue, perhaps because of the mill houses being built there. (Courtesy of William Trombley.)

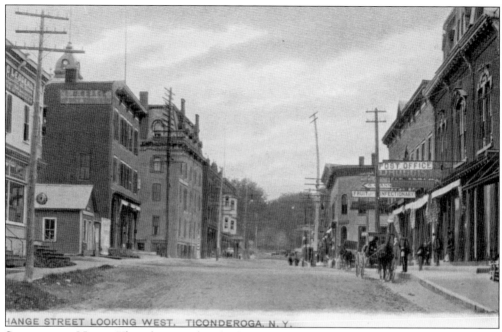

HANGE STREET LOOKING WEST, TICONDEROGA, N. Y.

Streetscape No. 2. This photograph is looking west on Exchange/Montcalm Street, roughly from in front of today's Community Building. The lower mill and American Graphite are behind the photographer, and Main Street/Champlain Avenue is at the next corner. Note the post office sign on the right. It will be many years before it moves up onto Champlain Avenue.

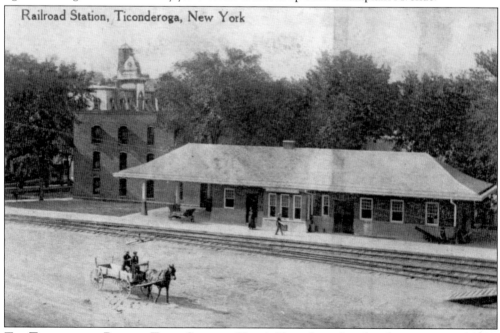

Railroad Station, Ticonderoga, New York

The Ticonderoga Branch Train Station. Here is Ticonderoga's railroad station around 1910. The firehouse is just to its right, and the roof of the Burleigh House is in the background with its water tower. Two spurs split off the northbound train tracks, with one using this station and the other continuing on to Lake George and the businesses at the upper falls.

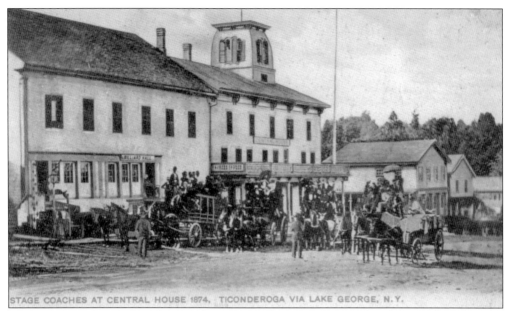

STREETSCAPE NO. 3. Before the great fire of 1875, stagecoaches arrived and departed for the Lake Champlain and Lake George steamships. The Central House (1828–1875) was the signature hostelry in its day. While its owner reestablished himself on North Main Street after the fire in a location later to be known as the Ti Inn, the Central House never regained its former glory. But in this picture and others, it lives on as a reminder that vision and hard work are the mothers of miracles.

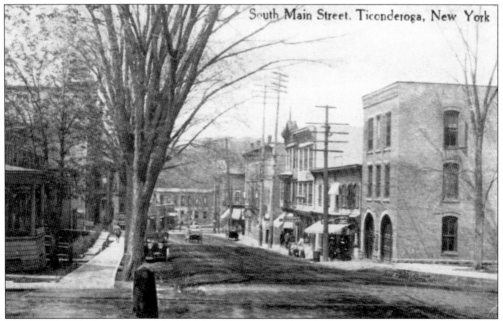

STREETSCAPE NO. 4. This c. 1910 image is of Main Street/Champlain Avenue looking north. The firehouse is on the right, and the Drake block is below that. The Burleigh House is barely visible on the left, and the Island Mill is dead ahead. Note the tracks on First (today's Algonkin) Street. (Courtesy of William Trombley.)

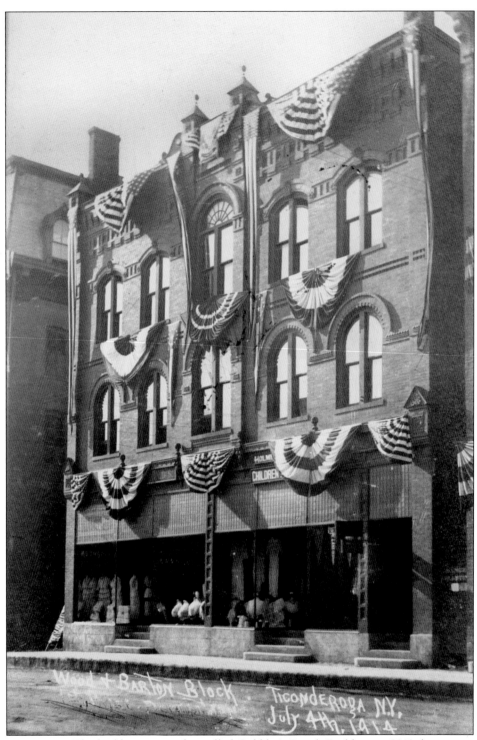

PEARLS, 1914. The building pictured is called Cobbler's Bench Building in 2012, but it was at different times called Pearls department store and the Wood and Barton Block. (Courtesy of William Trombley.)

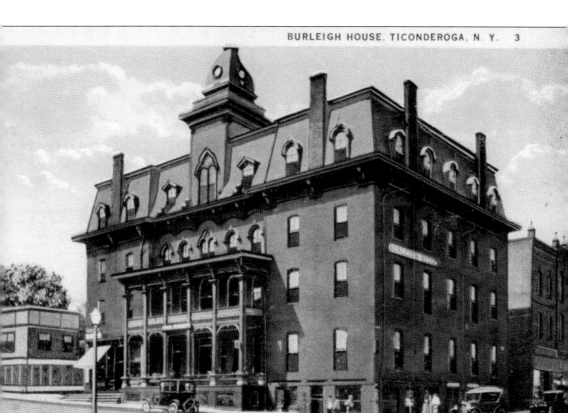

THE BURLEIGH HOUSE. Pictured is a full view of the Old Burleigh House, mentioned previously, on the corner of Main Street/Champlain Avenue and Exchange/Montcalm Street. In 1933, most of the street names in the village were changed to highlight Ticonderoga's colorful history. Destroyed by fire in 1953, this building more than any other said "Ticonderoga." Some time later, another Burleigh House was built on the spot that continues in business today. The loss of this old building was one of those moments when people will say "Where were you when" or "How did you hear" about the fire.

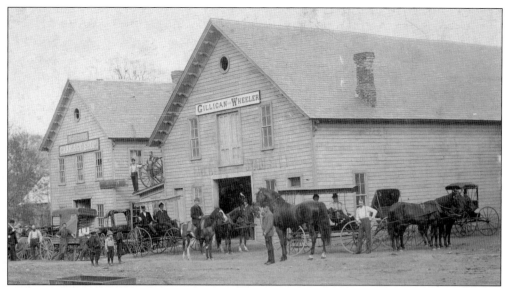

OLD BARN, ABOUT 1900. This building was just south of the Island Mill. Alexander Ostiguy erected this building about 1895 after tearing down the Ramsey wheelwright shop. One side of the building was a carriage shop, and the Gilligan & Wheeler side was a livery stable. It was listed in the 1893 Ticonderoga Directory, printed by the Champlain Directory Company, when Henry Wood rented the shop. The directory lists Eugene Wheeler as a liveryman (Gilligan & Wheeler) with the business at 29 North Main Street and a home at 9 Second Street. The 1885 D. Mason history of Essex County lists Alexander Ostiguy as engaged in the wagon-making business in the village, and the 1893 directory lists his occupation as a wheelwright, with a home address 2 Park Place Avenue. (Courtesy of Perry O'Neil.)

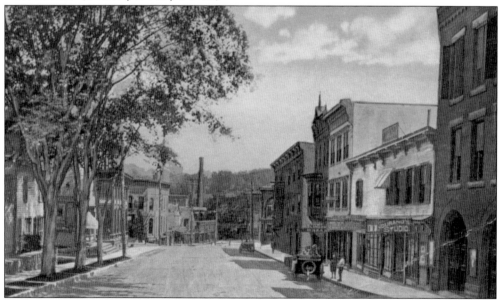

STREETSCAPE NO. 5. Similar to streetscape No. 4, this photograph was taken from a bit farther down the street. The Burleigh House and the Drake block show up better. So much of the story of these buildings is lost, probably forever. Ticonderoga, like many towns, lost much of its historical records in a variety of fires.

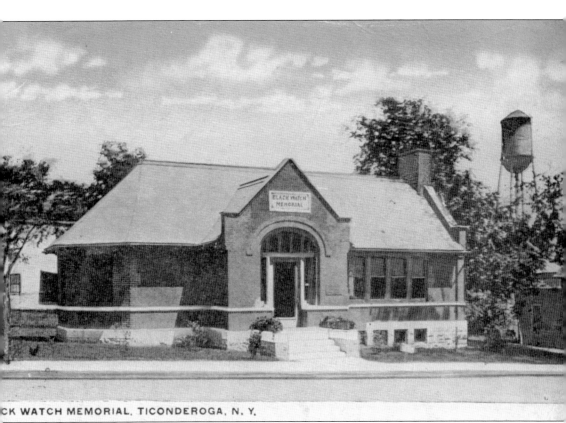

CK WATCH MEMORIAL, TICONDEROGA, N. Y.

THE LIBRARY. The Black Watch Memorial Library, a Carnegie library, was built in 1905 and not so long ago was expanded while celebrating its centennial year. The building has served Ticonderoga as a library and as a public learning institution for many years. Note the old International Paper Mill water tower in the background.

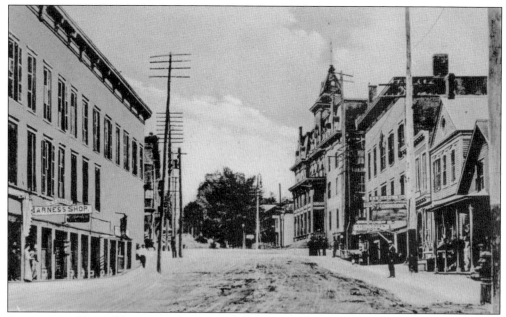

STREETSCAPE NO. 6. This view is looking uphill from North Main Street/Champlain Avenue. In the 1960s, somewhere on the right side was a barbershop. Up in the corner on the right is where the Bank of Ticonderoga Building would be in about 20 years. After the building on the left in the Atchinson block succumbed to fire, the area was transformed into the parking lot of today. Note that Aubuchon Hardware is expanding into that parking lot, a hopeful sign.

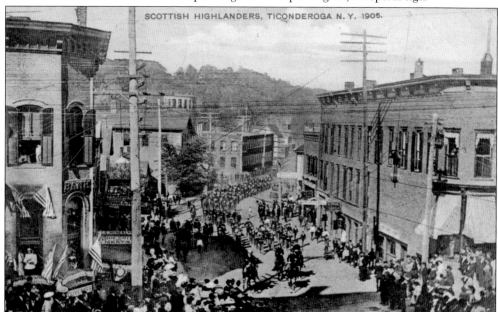

STREETSCAPE NO. 7. Uphill a little bit is the bank corner on the left, with the Atchinson block on the right as well as Island Mill. The Scots Highlanders visited Ticonderoga in 1905. The Black Watch regiment bore the brunt of the Marquis de Montcalm's successful defense of Fort Carillon in 1758. Here, in 1905, they paid homage to their fallen comrades. In Ticonderoga, one will see a lot of checkered black and green, the colors of the Black Watch military tartan.

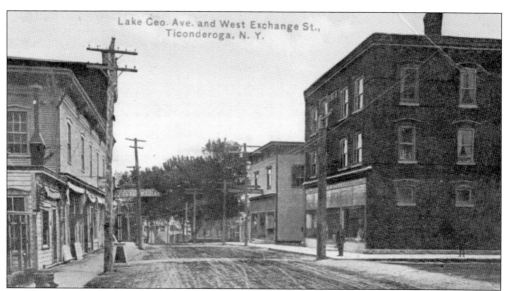

STREETSCAPE No. 8. Showing the intersection of Lake George Avenue and West Exchange Street, this c. 1915 photograph is looking east. The large brick build is a Laundromat today, with apartments upstairs. A few years before, there were two bridges here, one on Lake George Avenue and one on Exchange/Montcalm Street, as the roads passed over Spencer Creek. At the foot of Lake George Avenue, William Gale (who built the laundry building) would later build Peoples Garage in partnership with a man named Floyd Bennett. (Courtesy of William Trombley.)

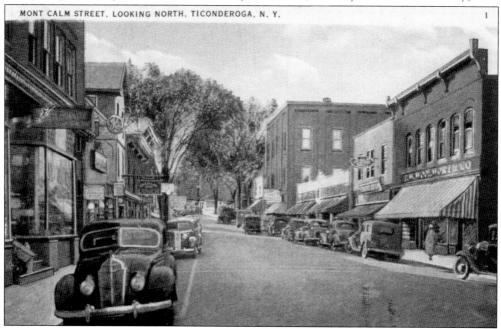

STREETSCAPE No. 9. Here is another view of "Downstreet." There are two things wrong with the title on this postcard. One, the street name is spelled Montcalm Street, and two, it is actually looking west. Otherwise, this is a nice period look at what became Ticonderoga's main street. Judging by the name on the image, however mangled, this photograph or at least the caption was created after the 1933 street name change. Note the Woolworth's building on the right.

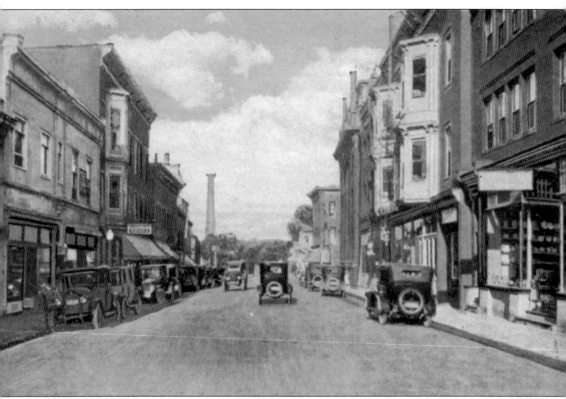

STREETSCAPE NO. 10. Moving back in time a bit from the last picture and looking east on Exchange/ Montcalm Street, lower mill is straight ahead, and the Burleigh Hotel and Drake block are right where they belong. Folks are showing off their new cars, business is booming, and nary a horse is in sight. These postcards let people look back and trigger memories from their pasts. Every year, the area's story changes a bit. When the opportunity permits, stories should be shared with schoolchildren, the hope of the future.

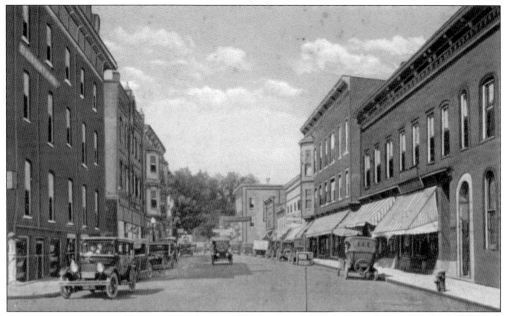

STREETSCAPE No. 11. Here, one looks west. The cars are bigger (mostly), and it looks like the Elks' building up next to the library. In the 1950s and 1960s, there were lots of awnings on the businesses downtown. It made keeping the sidewalk clear of snow a lot easier and allowed folks a chance too look at the window displays in any kind of weather.

STREETSCAPE No. 12. Pictured is Exchange/Montcalm Street. Just there on the left is the Black Watch Library, and second on the right is the Oddfellows lodge. The Knights of Columbus building is just west of the library. The building housed, among other things, the *Ticonderoga Sentinel* newspaper. In most, if not all, of the spaces between these buildings, taxi cabs operated. As a kid, if the day was hot enough and the walk uphill long enough, and if there was enough change in one's pocket, a ride home was in his or her future.

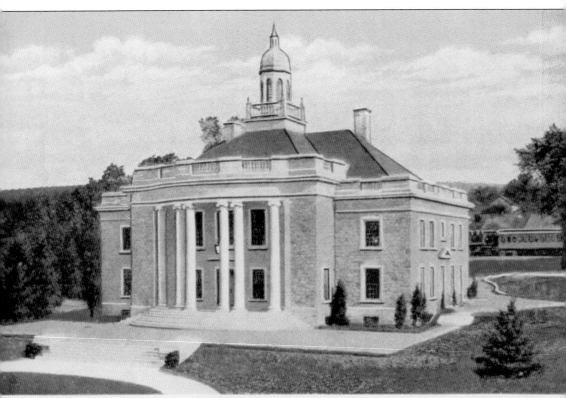

THE COMMUNITY BUILDING, TICONDEROGA, N. Y. 123742

THE COMMUNITY BUILDING. Ticonderoga's biggest benefactor and favorite son, Horace Moses, made his money in the papermaking business, but not in Ticonderoga, and lavished his fortune on his hometown. He erected this building and donated it to the town, which housed the village's offices in it for many years. After the dissolution of the village, town offices are now located in the building. Succeeding pictures will show other buildings Moses either donated or assisted in the process of building. Following in the footsteps of Joseph Cook, H.G. Burleigh, and Clayton H. Delano, as well as others, Moses elevated this old mill town to a level it would not have risen to without him.

THE POST OFFICE. The previous post office was in the Weed block on Exchange/Montcalm Street and can be seen behind the marching soldiers in another picture. This post office was built on Main Street/Champlain Avenue in 1936–1937 and still stands. Streetroad and Chilson also had post offices. Most of the outlying post offices were just desks in general stores. Streetroad's is a bit odd, as the area was known as Back Street or Ticonderoga Street, but when residents requested a post office with the name Ticonderoga Street, someone in Washington did not like the idea of two Ticonderoga-named post offices, so the sign came back "Streetroad," or so the story goes.

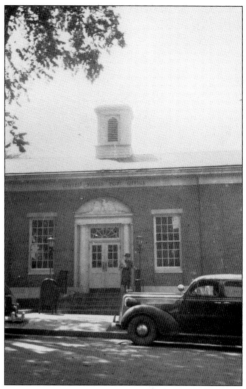

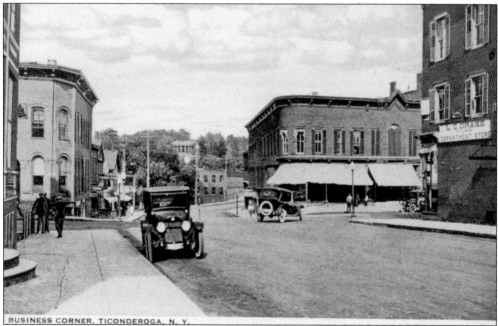

STREETSCAPE NO. 13. Here is a better look at the Bank block (though the Ticonderoga National Bank had not yet built its building). This image is also a good view of the Drake block (or at least a portion of it). It is somewhat sobering to note than none of these buildings exist today. (Courtesy of William Trombley.)

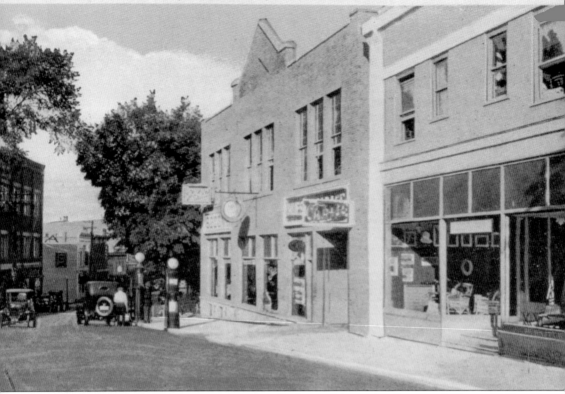

STREETSCAPE NO. 14. Backing up west on Exchange/Montcalm Street is Wilcox and Regan furniture store. This too will be lost to fire. Note the gas pumps right on the curb. Not long after this picture was shot, Ticonderoga prohibited curbside gas pumps. Right across the street from that store was a place called the Wigwam; its life ended as Ticonderoga's first bowling alley after having served as a vaudeville-type establishment.

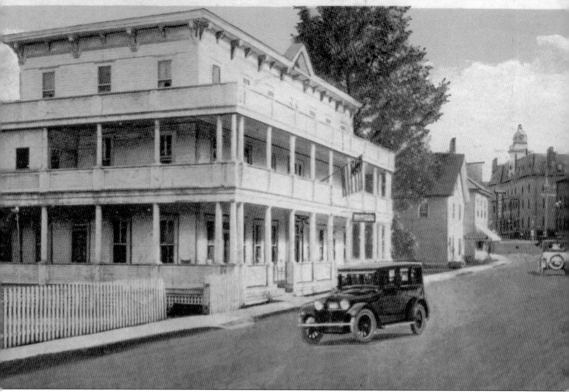

THE TI INN. Know by several names over its lifetime, from at least 1875 to 1953, it is remembered locally as the Ti Inn. Situated directly across from the Island Mill, it sat on North Main Street/ Champlain Avenue until the 1953 fire. Most of the fires in Ticonderoga were property damage only, but in this one, several people lost their lives. There was just a short interval between the Burleigh House fire and the Ti Inn fire, leaving Ticonderoga without a large hotel for the first time in almost a century. For the town and the families involved, this was one of Ticonderoga's saddest days.

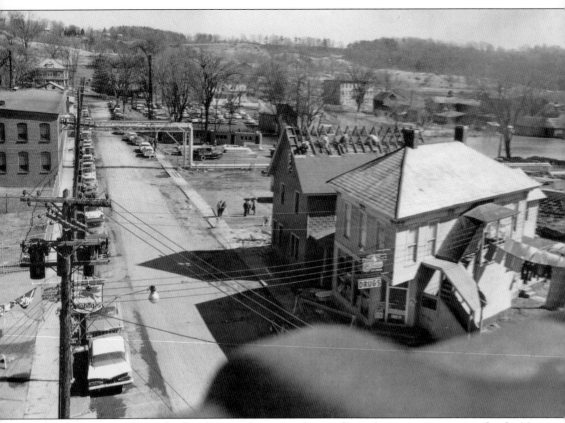

PREPARING FOR NO. 7. In this shot, workmen are dismantling a house in preparation for the No. 7 building. Note the vacant spot just before the pipes crossing the street where the Ti Inn used to be. The buildings in the upper right are the American Graphite company, a wholly owned subsidiary of the Joseph Dickson Company. This was taken in about 1960; by 1968, the graphite refinery will have also burned to the ground, ending over 100 years at the location. The north part of the Island Mill looks like it is already gone, as is the clock tower. Those homes will be gone, as will part of the street they live on. By limiting access to North Main Street/Champlain Avenue and the Frasier Bridge, a new road called Tower Avenue, named in honor of the old tower, will be constructed, and a new unnamed bridge will cross the stream just a bit farther east of this one.

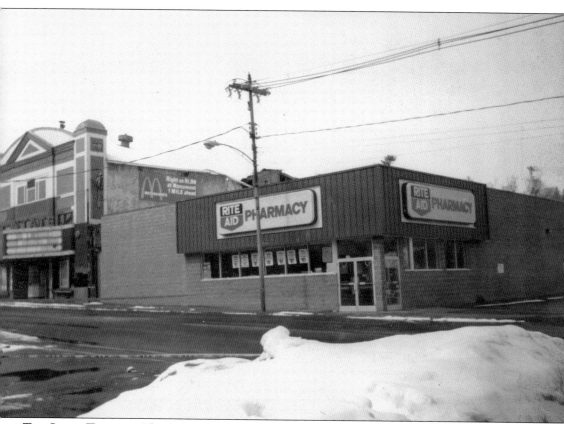

THE STATE THEATER. The State Theater was one of the main attractions in Ticonderoga for many years. The old opera house at the same site had been extensively remolded to produce the new theater. The free Christmas shows were favorites of the children. When it finally closed, Ticonderoga lost a spark it has not yet recovered. The closing of the old drive-in in Crown Point just to the north also brought an end to local movie nights. Folks now drive to Glens Falls to catch a movie or stay home and play a video or download something. The "new" Rite Aid building replaced a garage but now sits empty, as another, larger Rite Aid has been erected at the four corners to the north.

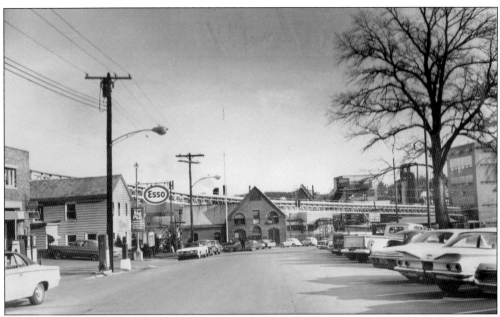

STREETSCAPE NO. 15. The 1888 Building/Ticonderoga Heritage Museum is in the center, and International Paper's lower mill is behind the building. Tower Avenue, on which is the town's garage, branches off to the left. Parking for the Community Building is on the right. It is not known what the 1888 Building was being used for at this time, around 1965.

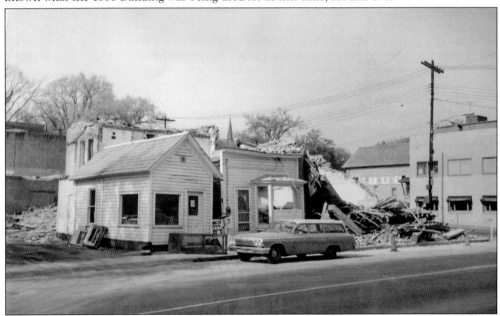

DRAKE BLOCK. In the 1970s, one more of the old post-1875-fire buildings meets its end. Here are the remnants of the old Drake block, behind which one can see the building that replaced the Burleigh Hotel. Today, Jay's Sunoco sits on that corner. Once, an elaborate brick wall stood behind those buildings. Despite the efforts of one of Ticonderoga's younger citizens, Steve Labatore, to save it, the brick wall is no longer there. It was behind his family's business, and tearing it down opened the alley behind the stores to the Community Building's lawn.

Five

SCHOOLS AND CHURCHES

THE OLD ACADEMY. Seen here is the old Ticonderoga Academy, sitting in what was known as Academy Park, which was halfway between the two villages (Alexandria and what became known as Ticonderoga or the lower village). Located in the "V" where Main Street/Champlain Avenue and the portage meet and surrounded by churches, the school was started by Clayton Delano and Joseph Cook at the turn of the century. As the State of New York evolved, mandatory education came into fashion, and the academy became a high school. Quickly too small, it was replaced by a much larger brick building in 1902. Ticonderoga's first high school opened its doors in December 1858, and 154 years later, its successor is still going strong. In January 1930, the present high school on Calkins Place started its first school year.

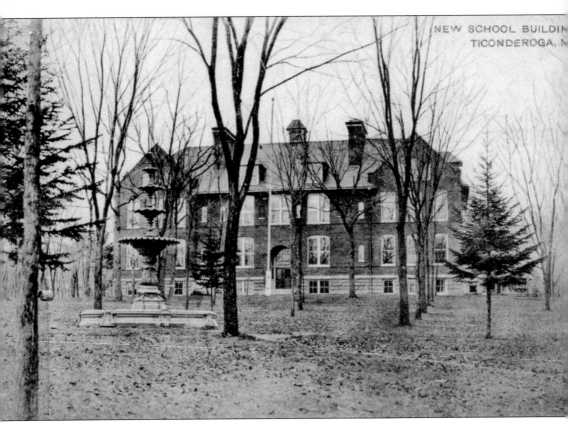

THE CENTRAL SCHOOL. A high school was constructed in 1902, known variously as the old high school, the Central School, and the community center. After the building was replaced as a school, the town court was moved to this building, and the youth center was here. This building played host to community members and their activities, like Ping-Pong, dances, parties, instruction, and meetings. Sadly, it was condemned and finally razed. The area where the school used to be is now used for the Ticonderoga Emergency Squad Headquarters. The many monuments on the site will continue to be looked at for generations to come.

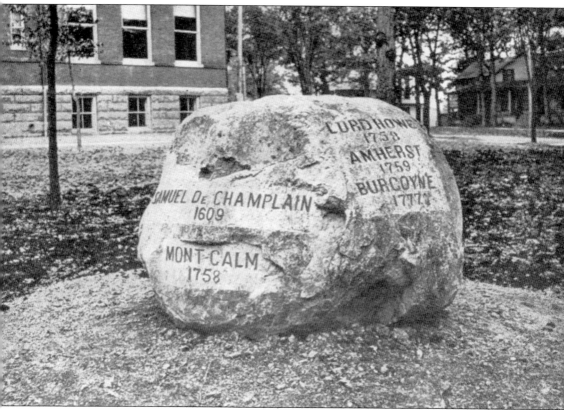

THE ROCK. It was Joseph Cook who had the rock inscribed with the names of famous people who had left their mark on Ticonderoga. He placed the rock before the main door of the then high school. It was his hope that schoolchildren would pass it everyday and nurture a love for this special place that was as deep as his own. This constant reminder, he hoped, would stir their imaginations and excite their interests. Unfortunately, today's students will likely never see it, unless the school does a field trip to this site.

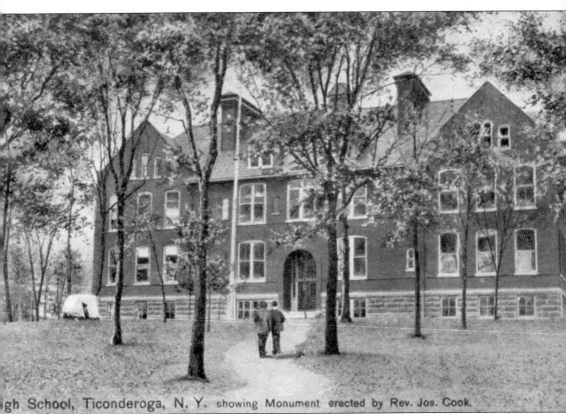

gh School, Ticonderoga, N. Y. showing Monument erected by Rev. Jos. Cook.

OLD HIGH SCHOOL. When the new brick school was built in 1902, the rock was much more off center; it is not known if that was by design or the builders just could not move it. In that time frame, new brick schools replaced almost all of Ticonderoga's older wooden schools; Ticonderoga had entered the modern age and done it ahead of several larger towns. Release time, when schools released children early to attend religious education, must have been easy with the majority of the churches within two and one half blocks. The only thing lacking at the old high school was an athletic field; however, sports teams used the field located next to what would become the new high school on Calkins Place. The old school building was taken down in 2001, and the new Ticonderoga Emergency Squad Headquarters sits in its place.

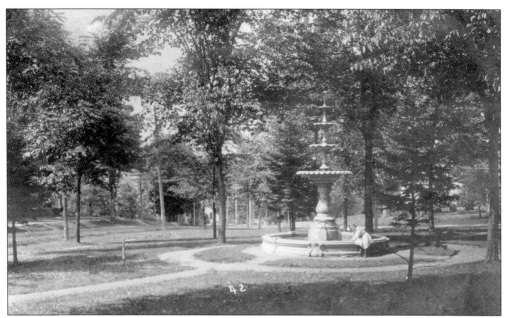

THE FOUNTAIN. Back before the Great War, the high school was between the villages (Alexandria and Ticonderoga) on the grounds of the old academy. In Academy Park, there was this lovely fountain, among several other monuments. A water line from Lake George was routed down this way to the lower mill and connected to this fountain. But as the mill's need for water increased, the fountain got less and less water and finally ran dry. Eventually becoming an eyesore, it was melted down in patriotic fervor, and the iron was used for weapons.

E VILLAGE PARK, TICONDEROGA, N. Y.

ANOTHER VIEW. Seen here is another view of the old fountain. The town fathers were adding what they could to make this the village square.

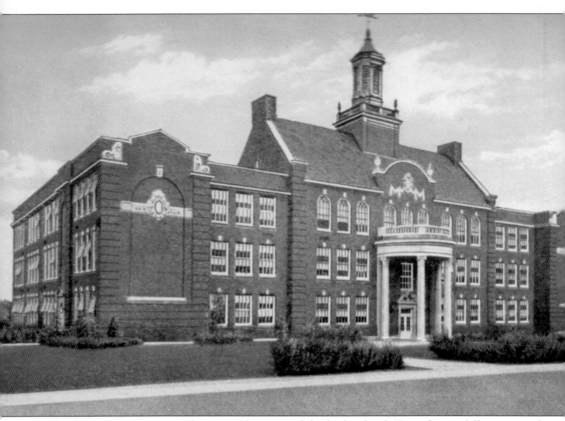

THE NEW HIGH SCHOOL. This is a 1950s view of the high school. Ticonderoga fully renovated the building and added a new right wing in 2011. Keep in mind that street names in Ticonderoga changed drastically in 1933; the new school was opened on Fourth Street in 1930. The street later became Fredericks Street, then Calkins Place, named after local businessman William E. Calkins. Also early in 1933, there was a bad fire in the new building, but Ticonderoga quickly rebuilt, and that building (with several modifications) serves to this day. In 1964, the grade schools were merged into a new building on Alexandria Avenue that also continues to serve the community today. (Courtesy of William Trombley.)

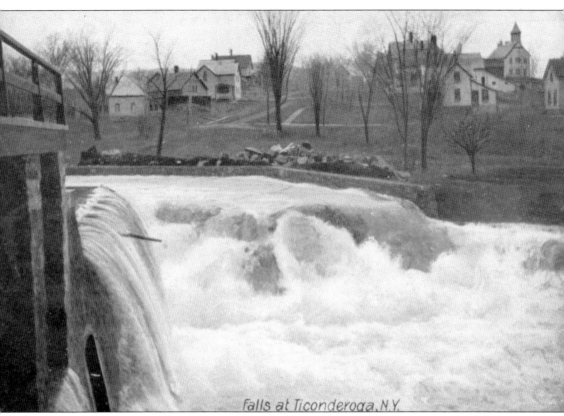

Falls at Ticonderoga, N.Y.

THE FIRST WEEDSVILLE SCHOOL. While the photograph is predominately showing the middle falls/D dam, the first Weedsville school on South Wayne Avenue/Prospect Street is also visible. John Street ran behind the building all the way to Exchange/Montcalm Street. When the new brick building was constructed behind the school pictured, part of John Street was closed off. In place of the old wooden school, a new modern house was built that sits happily there to this day.

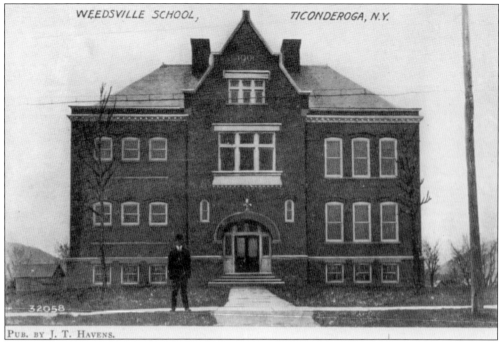

THE SECOND WEEDSVILLE SCHOOL. This is the school folks remember, but most remember it as Weedville. Over the years, the "s" kind of went silent. There was a time when this area was called Weedsville Park, after the second wife of Joseph Weed, Mary Hay Weed, started selling off the land. Today, the local Stewarts gas station and convenience store occupies that spot.

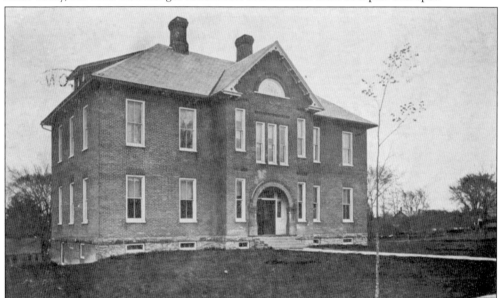

ALEXANDRIA SCHOOL. And here is the second Alexandria school; the first sat on the corner of Lord Howe Street and Alexandria Avenue. It is not certain whether or not the old building became a part of the house that still stands there. This building was closer to what became the main village and the high school. Today and for the last many years, this building has been used as an apartment house. (Courtesy of William Trombley.)

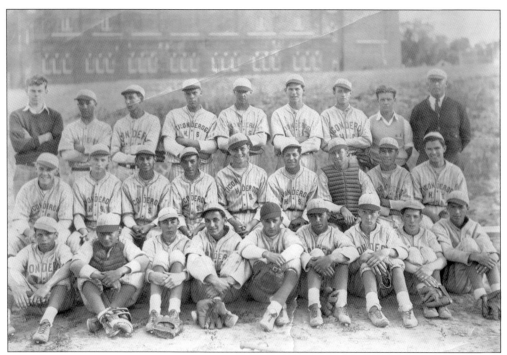

THE HIGH SCHOOL NINE. The high school seasons seemed to revolve around football, basketball, and baseball. Here, the Ticonderoga High baseball team (in the mid- to late 1930s) poses for the photographer at the school's field. The thing about that field was that any really good hitter could rocket the ball into one the houses that lined the field. Teams used to play each other until all the balls were gone, either into the houses or the river, and the winner was the team that was ahead when the last ball disappeared. (Courtesy of Perry O'Neil.)

CLASS OF 1945. The graduating class of 1945 Ticonderoga High School is pictured here. Some of these young men and women went on to build the Ticonderoga of today. Some of the students went on to become teachers, merchants, or mill workers. The Ticonderoga school system was rated very high in the state in those years. Many of their family members and former classmates went into the service, entering an exciting but very dangerous world.

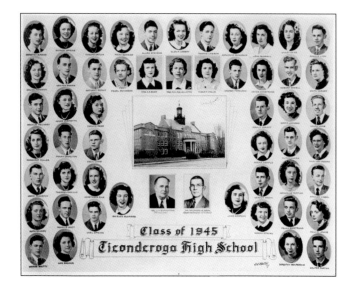

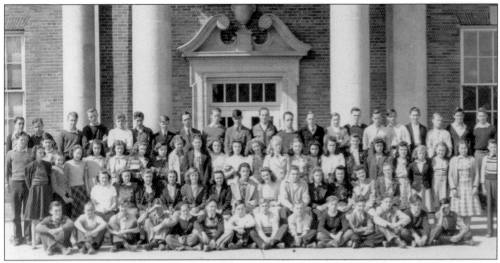

CLASS OF 1948. During the war years, paper was a scarce commodity (as was money). Where Ticonderoga High yearbooks were common in the 1930s and again in the 1950s, few exist for the 1940s. The 1940 yearbook was interesting; the book was available for purchase, but other than the graduating class itself, the pictures were optional. Students were able to pick and choose the picture they wanted and could pay for. (Courtesy of Perry O'Neil.)

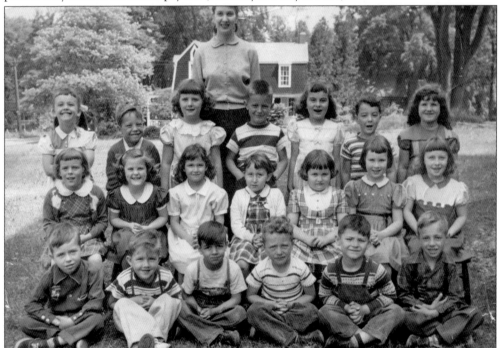

KINDERGARTEN CLASS OF 1952. The kindergarten class of the Alexandria school in Ticonderoga is pictured here. Students are "upper falls kids," never to be confused with the Central School or Weedville, Chilson, or Streetroad kids. Behind them but before the house ran one spur of the railroad on its way to Lake George, and to their right was the school building. Most of these children walked to school. In Ticonderoga, those days are gone, as school buses now ply the streets twice a day.

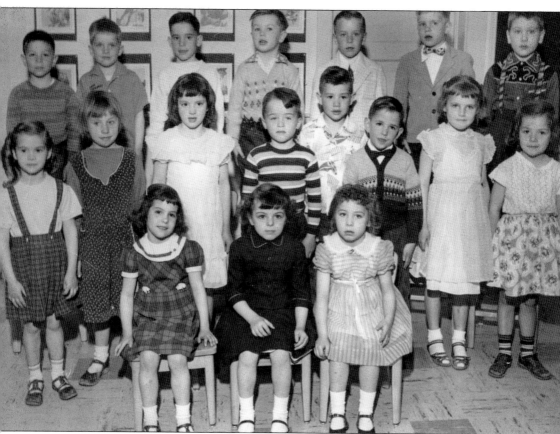

1956–1957 School Year. Here are some of the Streetroad schoolchildren in the first grade in the class of Mrs. Brock (née Woods). Streetroad never got a brick building, and the old building still stands today. After its original construction and expansion, it was retired when the local schools were merged. It did continue in service as a restaurant for some years but has fallen out of use today. It is said the Streetroad school was mainly populated by Chilson students. If so, that would explain the close ties these two hamlets have. Streetroad has been called the breadbasket, for Ticonderoga as its fertile soil is mostly farmland. Many of these children grew up on those farms and orchards. (Courtesy of Perry O'Neil.)

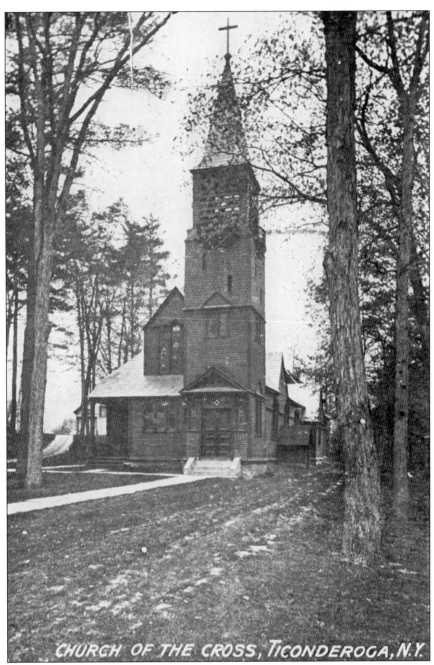

CHURCH OF THE CROSS, TICONDEROGA, N.Y.

THE CHURCH OF THE CROSS. The Episcopal church was first used for a church service in 1870 but was destroyed by fire in 1884. Its replacement building, seen here, was opened in 1886 and continues in service to this day. Also known as the Church of England or Anglican Church, the church flourished here in Colonial days, and a lot for the church to use was prepared in Alexandria. After the Revolution, however, the denomination vanished. Many New Englanders were Congregationalists, and that denomination was well represented here. As time went on, the Episcopalians returned, and on this spot they erected their first building. Just across from Academy Park and the high school, they prospered.

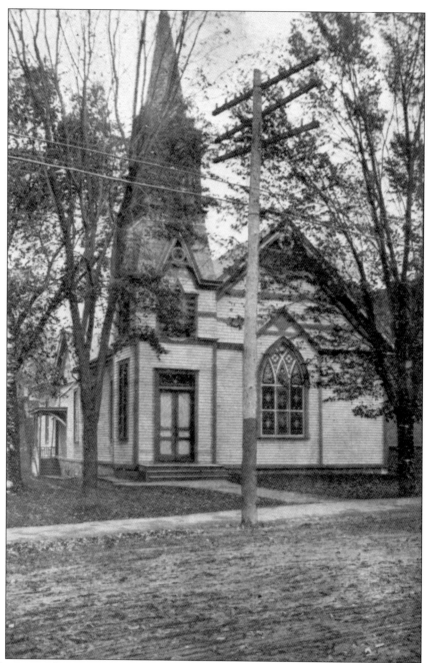

THE METHODIST CHURCH. The First Methodist Church in Ticonderoga was long situated downtown near the old theater. Built in 1870, it had a rocky start. Financial problems plagued the small structure, not to mention the occasional flood from the Spencer Creek days. In 1966, a large new building was built near the Moses-Ludington Hospital, which solved all the church's problems. It still serves the Ticonderoga community today. The new church complex also houses Ticonderoga's food pantry and its thrift shop. Several churches and local organizations host food drives and bake sales to help stock the shelves. Each year at Christmastime, a Holiday Train arrives to help collect money and food for the pantry.

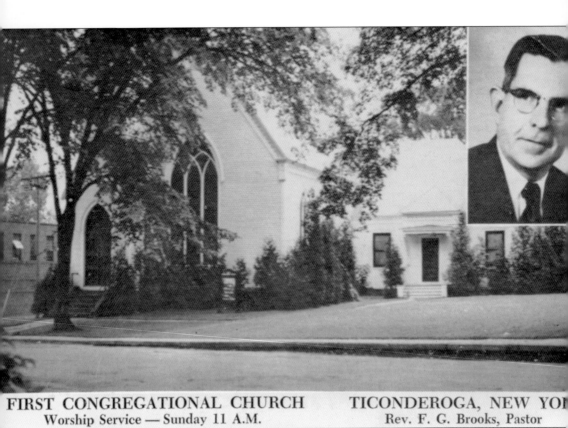

FIRST CONGREGATIONAL CHURCH
Worship Service — Sunday 11 A.M.

TICONDEROGA, NEW YO[R]
Rev. F. G. Brooks, Pastor

THE CONGREGATIONAL CHURCH. Ticonderoga's First Congregational Church, organized locally in 1809, constructed its first building in the Mount Hope area. This building was erected in 1874 and was razed in 2000; the space is now used as a parking lot for nearby businesses. It must have been interesting to sit in Sunday services and have a train pass on the tracks just to the left of the building. (Courtesy of William Trombley.)

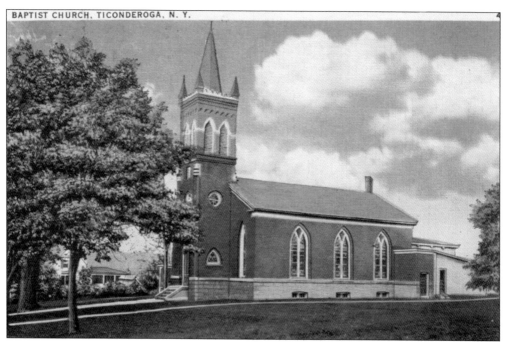

THE OLD BAPTIST CHURCH WITH A STEEPLE. Ticonderoga's Baptist church and two others sit within a block of each other, more or less adjacent to where the old high school used to be. Around 1836, this building was erected to serve the growing Baptist congregation in Ticonderoga.

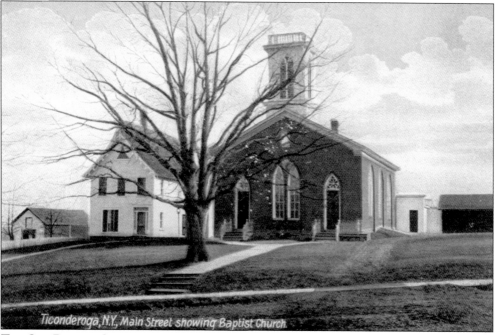

THE OLD BAPTIST CHURCH WITHOUT A STEEPLE. This is another, earlier picture of the church without its steeple. To the building's left was the parsonage, which no longer stands; its roof was built in the shape of a cross. The main building, built to last but with many modifications, including a large concrete section to the rear of the building, still serves the congregation today.

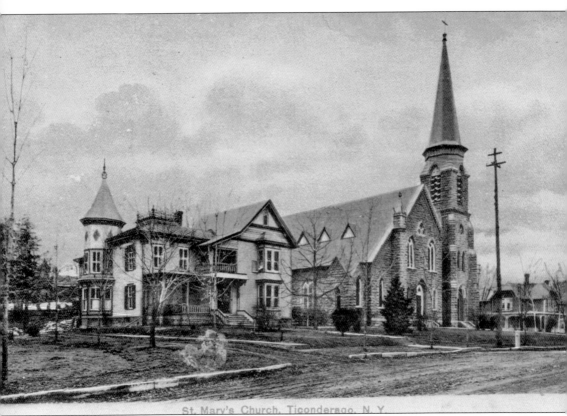

St. Mary's Church, Ticonderago, N. Y.

THE ROMAN CATHOLIC CHURCH. Here is St. Mary's Roman Catholic Church, dedicated in 1892 by Bishop Henry Gabriels. In 1942 and 1959, fires devastated the church, but repairs were quickly made, and it stands today, a monument to the faithful. In 1958–1959, a parochial school was added behind the main structure, and at one time, a convent was built just across Father Jogues Place/ Second Avenue. Arguably the first Catholic church was built out near where the new mill road meets Route 9 North/22. There is a small cemetery there that was next to the church. It is a sure thing that the French had at least a chapel here in the 1750s.

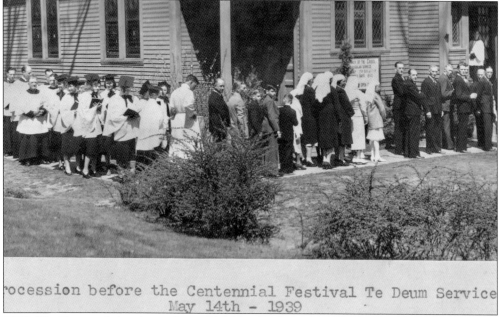

procession before the Centennial Festival Te Deum Service
May 14th - 1939

1939. The Episcopal church members gather outside the building in 1939 for a centennial service. They must have established their church in 1839, which was several years before they built their first church building. Outside precessions went out the back door of the church, around the building, and into the front door and down the aisle. (Courtesy of the Church of the Cross.)

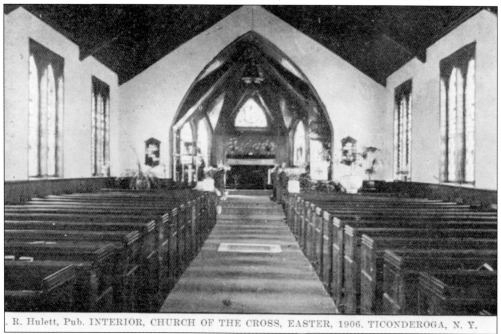

. R. Hulett, Pub. INTERIOR, CHURCH OF THE CROSS, EASTER, 1906. TICONDEROGA, N. Y.

INSIDE. Here is the interior of the Episcopal church in Ticonderoga in 1906. Subsequent renovations have added lecterns nearer the congregation. The congregation has this picture hanging just inside the front door of the building. The building was erected in the shape of a cross. In later years, the congregation added Sunday school/meeting rooms in the back.

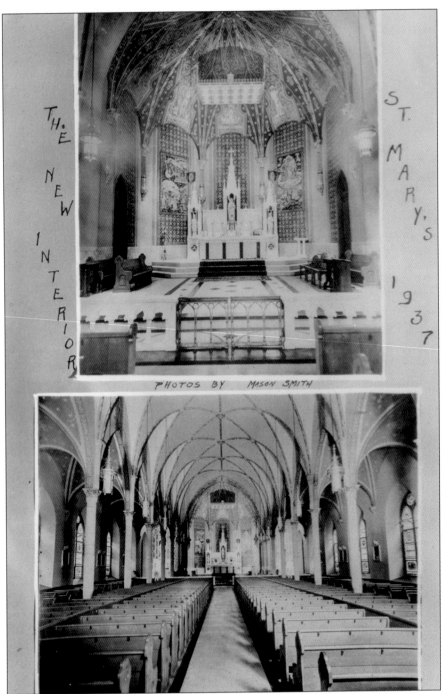

THE NEW INTERIOR

ST. MARY'S 1937

PHOTOS BY MASON SMITH

ST. MARY'S. Here is an internal view of St. Mary's Roman Catholic Church in Ticonderoga. This photograph of the interior of the church was taken after some renovations were done. Mason Smith was Ticonderoga's main photographer for much of the 20th century; if it was important, he took the picture. Generations of schoolchildren used his name in place of the word "slow." But the time he took to get his shots preserved those faces and places to their best advantage for posterity.

Six

ROUND THE TOWN

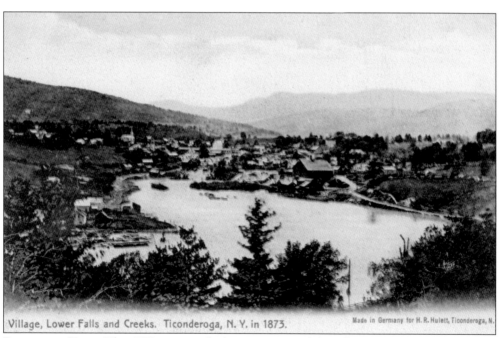

Village, Lower Falls and Creeks. Ticonderoga, N. Y. in 1873. Made in Germany for H. R. Hulett, Ticonderoga, N.

ROUND THE TOWN. This 1873 picture is looking west toward the village from about where today's Route 74 meets the Fort Road. The wide basin and docks below the lower falls show themselves to a public that is too young to remember them. The "Long Bridge," located near where the sewage treatment plant is now, carried foot and horse traffic over the flowing water. At that time, canal boats and barges plied these waters; there were no trains yet to take Ticonderoga's products north to Montreal or south or New York City.

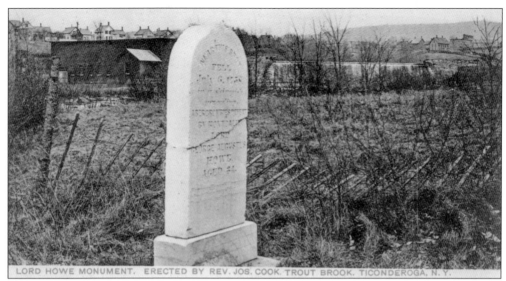

LORD HOWE MONUMENT. ERECTED BY REV. JOS. COOK. TROUT BROOK. TICONDEROGA, N. Y.

LORD HOWE. This stone marks the area where George Augustus Howe, third Viscount Howe, was killed in a firefight with retreating French and Indian troops. It is thought that his death led directly to the British defeat at Carillon in 1758. In the 20th century, a stone was dug up that appears to have been used as his grave marker. Note also behind this monument the old C dam and powerhouse. The mill houses are lining Lake George Avenue on the left side of the picture. This stone is no longer on that site, but in 1959, a new marker was raised not far away with most of the same information, and a New York State historical marker was placed at the site of the old stone.

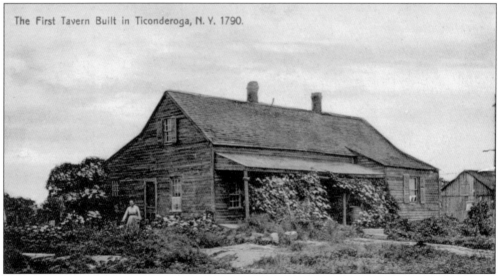

The First Tavern Built in Ticonderoga, N. Y. 1790.

THE OLD TAVERN. There has been some discussion on where this first tavern built in Ticonderoga was located. The majority opinion is that it was at the upper falls near the Bridge Street and Alexandria Avenue Bridge. And the rocky ground gives some credence to that opinion. There are others who advocate for a Streetroad location. It was likely in Alexandria, and imagine this was the tavern that Revolutionary veteran Prince Taylor ran near that location. It was said to be the liveliest place in town. Prince Taylor served on a ship and in the infantry during the war and then settled in town. There is no record of his death or of any marriage.

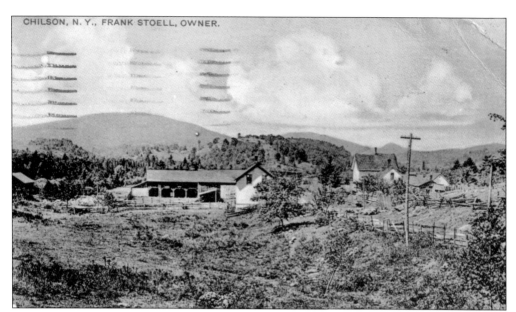

CHILSON STORE. In the Chilson hamlet, Frank Stowell (1851–1925) ran a general store for many years, and following his death, the family continued to operate it. This would go on to be the location of the post office. Other than the church, the center of most activity in the small hamlet happened at this building. The Stowells had migrated east from Schroon Lake, where David Stoel had settled after serving in the Revolutionary War. He is buried there in the Stowells' cemetery near the house he had built, which still stands today.

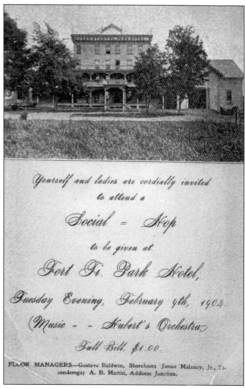

HUBER'S FORT TICONDEROGA PARK HOTEL AND RACETRACK. Here is a 1904 invitation to a social gathering. The event was followed by a race of Ticonderoga-raised Thoroughbred horses the next day. Huber's had it all. Roughly near the old WIPS transmitting tower or between the new Ticonderoga train station and Lake Champlain, the hotel had a terrific view and plenty of room for the horses, and old Fort Ticonderoga was half a mile away. Ticonderoga was filled with racetracks in those days. The act of raising and running horses was becoming a big industry here.

Yourself and ladies are cordially invited to attend a

Social ═ Hop

to be given at

Fort Ti. Park Hotel,

Tuesday Evening, February 9th, 1904.

(Music ─ ─ Hubert's Orchestra)

Full Bill, $1.00.

FLOOR MANAGERS—Gustave Baldwin, Shoreham; James Malancy, Jr., Ticonderoga; A. B. Martin, Addison Junction.

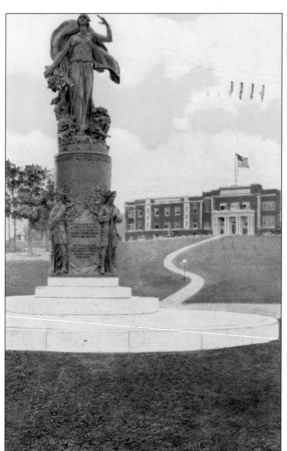

THE MONUMENT. Ticonderoga is full of monuments, but this is the most important. Here is a view of the Liberty Monument, which was yet another gift presented by Horace A. Moses to Frank Moses (supervisor of Ticonderoga). Unveiled on August 16, 1924, it is a tremendous asset to the town he loved. As a sculpture, it is wonderful, and as a reminder of what happened here, it is inspiring. It is also the centerpiece of a traffic circle, which often confuses drivers.

"THE MONUMENT AND THE HOSPITAL." Here it is again, this time showing the Old Moses Hospital, which was at the time of this picture the nurses' pavilion, in the top left behind the trees. To its right, the "new" Moses-Ludington Hospital tops the hill. Some artistic license was taken with this postcard, as the road does not show up in the picture. This a favorite spot to take pictures during parades. Getting a float, marching unit, or fire truck along with the monument makes for the best parade photographs.

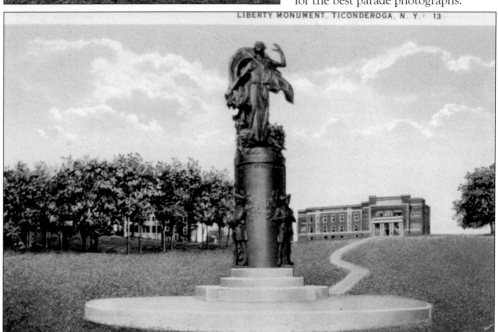

LIBERTY MONUMENT, TICONDEROGA, N. Y. · 13

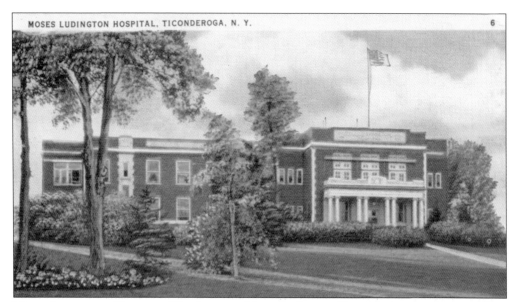

Moses-Ludington Hospital. The then-new Moses-Ludington Hospital, the one of more modern memory, had another wing added on the right side. Horace Moses donated most of the money for the original hospital, and a friend of his helped donate money for the new bigger and better hospital. The building pictured was built in 1920–1921. *Patches and Patterns*, published by the Ticonderoga Historical Society, mentions that the hospital was expanded to the right in 1946. The structure was sadly demolished in 2012.

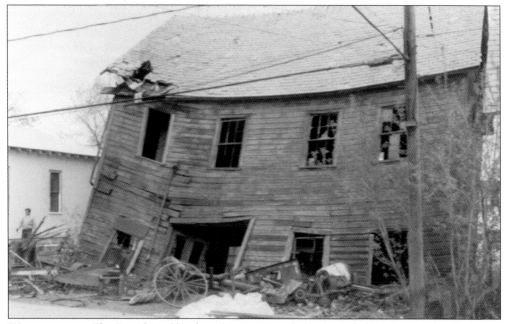

Wheelwright. The David A. Chapleau (c. 1868–1948) wheelwright/blacksmith shop is shown in its final days. David came here from Montreal about 1893. In later years, he operated this shop with his son Edward. Here, the building sits on Wiley Street, waiting for nature to take its course. For about 100 years, this building and its owners served Ticonderoga's community. Today, a modern building sits on that site, and this old building fades into a memory.

IN THE BEGINNING. The Ticonderoga hospital looked like this; in the planning stages, it was called the Shattuck Memorial Hospital, but it first opened its doors as the Moses Hospital. After this hospital was outgrown, a newer and larger brick building was built to its right in 1920–1921. This building then became the nurses' pavilion. There had been a farmhouse on this site, and the plan was to take down the house and build the hospital on that foundation. But after taking down the house, it was determined that the foundation was not good enough, so the building was erected on a new foundation.

THE NURSES HOME. The hospital has started a tradition that it will continue for over 100 years; the tradition is moving or expanding slightly north when it is time for more construction. As this hospital was superseded by a new one just to the north, so that one was also superseded by yet another just to its north. This building, with very extensive modifications, continues to exist today.

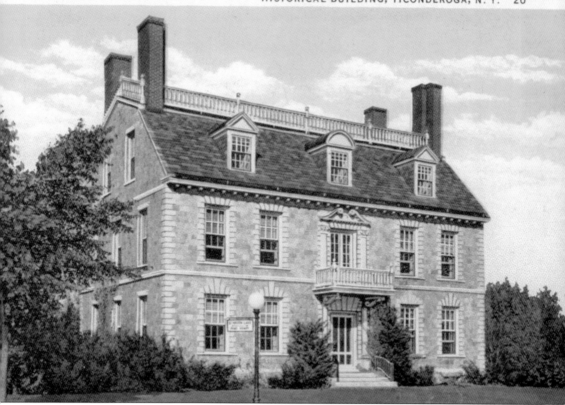

THE HANCOCK HOUSE. Built as the headquarters for the New York State Historical Society and donated to it by none other than Horace A. Moses, it currently houses the Ticonderoga Historical Society, its library, and museum. Situated on Moses Circle, it also shares the venue with the Liberty Monument and sits across from the onetime Moses Hospital. It is one of Ticonderoga's crown jewels, providing an elegance seldom seen this far north and a peek into a bygone era. Moses had it built as a replica of the home of Thomas Hancock (John Hancock's uncle) in Boston.

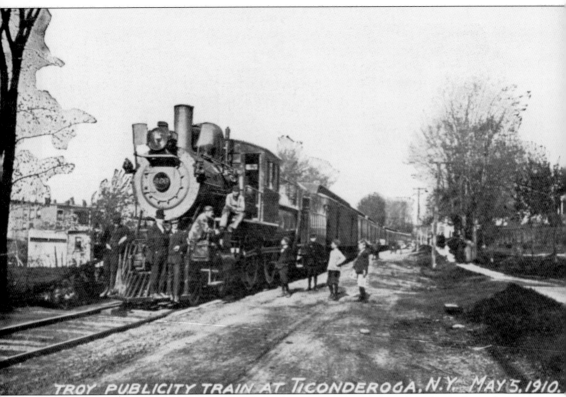

TROY PUBLICITY TRAIN AT TICONDEROGA, N.Y. MAY 5, 1910.

TRAINS. Trains became the lifeblood of Ticonderoga as a successor to the lake and canal system. Tracks ran all over town to feed the many industries and to take their products to market. This publicity train is parked on First Street (today's Algonkin Street or as some call it the one-way) and would shake every building on the street as it went through. Mark Wright maintains a wonderful Web page, www.tibranch.com/indexz.html, that explores the history of the railroads in Ticonderoga in extensive detail. As Mark points out, this train was sent out by the city of Troy to promote the local businesses. It sat on the track there most of the day, leaving to continue north about 6:30 p.m.

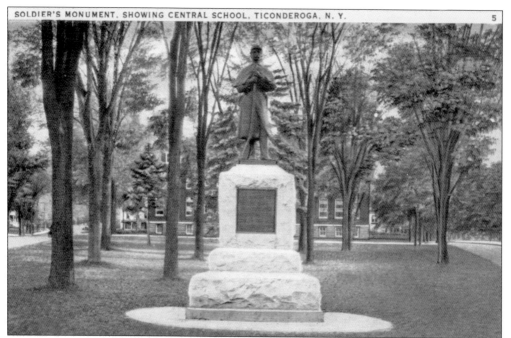

SOLDIERS MONUMENT. Here is view of the Civil War monument erected to commemorate the soldiers who fought in the Civil War. At the foot of Academy Park, which is Artillery Park today, stands Ticonderoga's memorial to that bloody conflict. The prime mover for getting this monument erected in 1916 was Clayton H. Delano, the president of the Ti Pulp and Paper Company. On July 4, he presented the monument to the town and to the local lodge of the Grand Army of the Republic.

THE JEFFERS HOSE. The Jeffers Hose Company was across from the Ticonderoga High School on Calkins Place. The building was erected in 1911 and abandoned some time in the 1970s, when the fire departments were merged into the same building. Though found in the same location, the departments remained separate until 1991. Gone are the days when the Jeffers Hose would play water polo with the Defiance Hose, with the Defiance Hook and Ladder looking on wistfully.

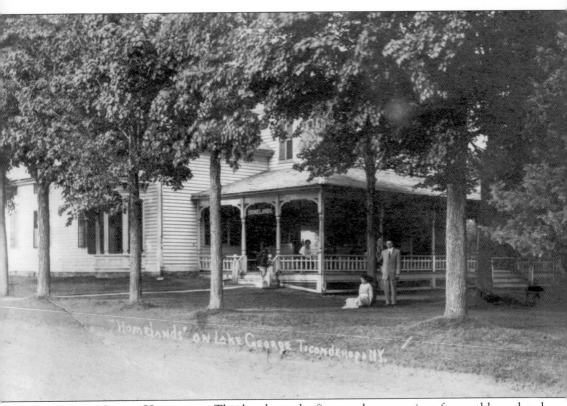

A PLACE CALLED HOMELANDS. This hotel was the first northern terminus for northbound and southbound passengers traveling from or to Ticonderoga on Lake George. Later, with larger boats plying the lake's waters, the landing at Baldwin was used and is still today. After serving as a great rustic hotel and travel station and being the place to hold large parties and receptions in Ticonderoga, it fell into disrepair and got the reputation for being haunted. Gone were the days when its large bell called folks to lunch and dinner. A sad end to a great Ticonderoga building, in its last days, it changed hands several times until it finally found no hand to want it. It found its way back into the public's attention when the wartime infantry landing craft destined to become the MV *Ticonderoga* was put back together on its storied grounds in 1950.

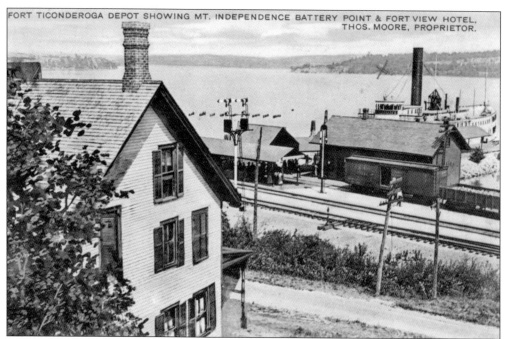

FORT TICONDEROGA DEPOT SHOWING MT. INDEPENDENCE BATTERY POINT & FORT VIEW HOTEL, THOS. MOORE, PROPRIETOR.

PORT MARSHAL. Also known as Montcalm Landing, Port Marshal is pictured looking east. In the immediate foreground are the Fort View Hotel and Lake Champlain, with Vermont in the background. The hotel is now a restaurant and one of the oldest in the area. The Ticonderoga train station, also in the picture, was moved up beyond the fort some time in the 1970s, and long before that, a tunnel was dug beneath the fort entrance so that the trains would not disturb the tranquility of that venerable site. Before the trains came to town, stagecoaches would meet the steamer passengers and move them between the town and the lakes.

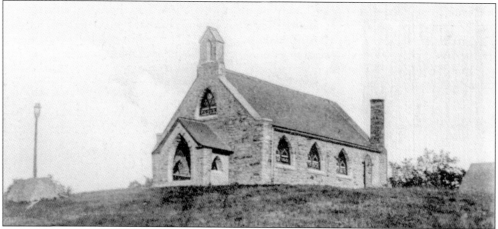

VALLEY VIEW CHAPEL. Another gift from Horace Moses, the Valley View Chapel, perched on a low hill in South Ticonderoga, was dedicated in 1901. It overlooks the Valley View Cemetery. Attached to no particular denomination, it is available for public use as needed. Behind the cemetery on its north side winds Trout Brook. Meandering through the Lord Howe Valley, it passes through the Ticonderoga Golf Course and past the place where Maj. Robert Rogers fought a losing battle with his French and Indian foes. Trout Brook merges its muddier waters in with the Lake George outflow of LaChute River.

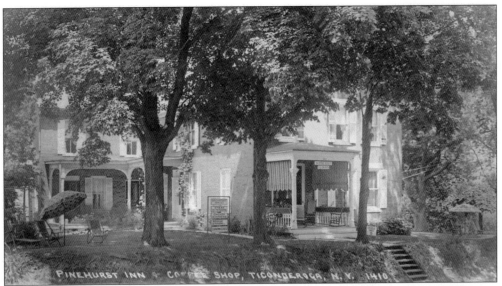

PINEHURST. This was once the home of both Joseph Weeds, the creators of Weedsville and Weedsville Park. It was replaced in the 1960s by the "new" A&P Building, which is today's Montcalm Manor. In Pinehurst's last days, it was something of a showcase. One could stop in for tea or coffee and a bite to eat, stroll through its garden, chat with friends, or stay the night. When the first Joseph Weed built it, it was his home, with his mercantile store attached on the left. Deeds in this section of town often go back to Mary (Hay) Weed, the second wife of the second Joseph, who later also owned it.

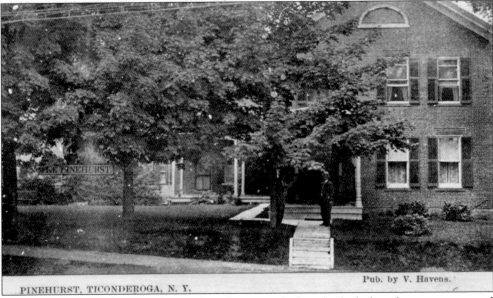

PINEHURST REPRISED. Here is a better idea of how it might have looked when the two men named Joseph and their families lived here. One Joseph had his lumbering empire centered on the upper falls, and the other had his mercantile operation on the lower falls. About 10 years apart in age, they lived very similar lives. More is known about Joseph Weed, but Joseph S. Weed served in the New York State Assembly in 1833 from Ticonderoga. And both men served the town as town supervisors.

CLIFFSEAT. The Joseph Cook residence was out in South Ticonderoga in the Lord Howe Valley. After an advanced education for his day and traveling the world over, he came back home and dreamed the dreams that helped build the town of today. A noted lecturer and historian, he wrote a small book in his youth, called *Home Sketches of Essex County*, from which much of Ticonderoga's history is drawn. His vision softened the hard edges of what was then very much a frontier town. Cliffseat, like the Chapleau wheelwright shop, slowly weathered away.

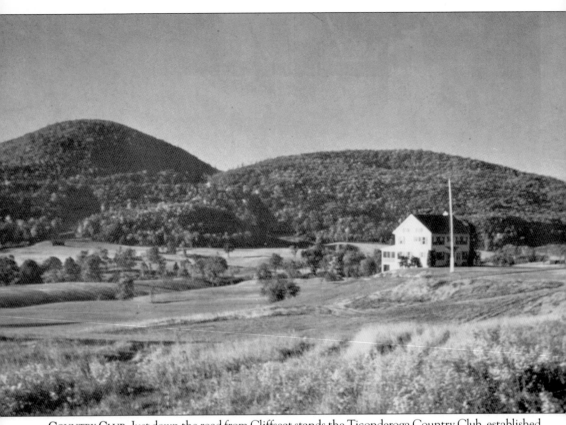

COUNTRY CLUB. Just down the road from Cliffseat stands the Ticonderoga Country Club, established in 1925. Formally a farmhouse, the gently rolling hills of the Lord Howe Valley provide the perfect setting for a unique 18-hole golf course, with nine holes opening in 1926 and the full 18 in 1932. Bisected by the meandering Trout Brook, which impacts seven of the 18 holes, the golf course's many small bridges add to the picturesque setting. Backed by the scenic Three Brothers Mountain, it also hosts the Emeralds Restaurant with fine cuisine and excellent service.

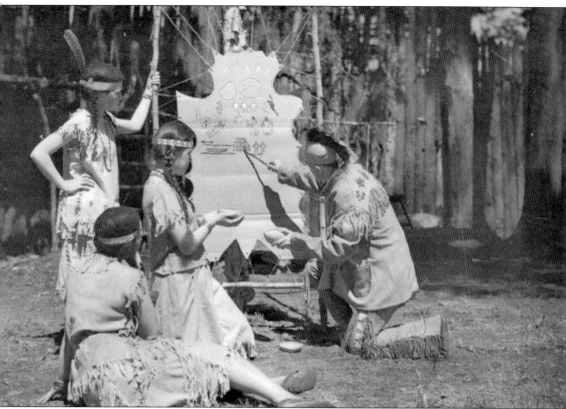

THE INDIAN PAGEANT. Every August for many years, starting about 1931, Ticonderoga hosted an Indian pageant. At one time, more than 100 people participated in the event, with several thousands viewing it. Thomas Cook was the father of the pageant and set it up partly to correct the false opinions common in that day about Indian culture. While the name itself would be considered politically incorrect in today's world, local citizens, coached by Native American advisors, put on a show in the old Forest Theater out in the woods.

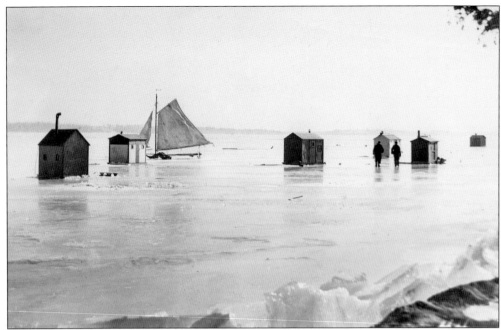

ICE FISHING. Here are a few fishing shanties out on Lake Champlain. Local lakes and ponds abound with shanties when it gets cold enough, and modern shanties have all the creature comforts. It strikes visitors from more southern regions as odd when trucks and cars drive out onto the ice, but after a few test holes, the fishermen know just about how much weight the ice will hold.

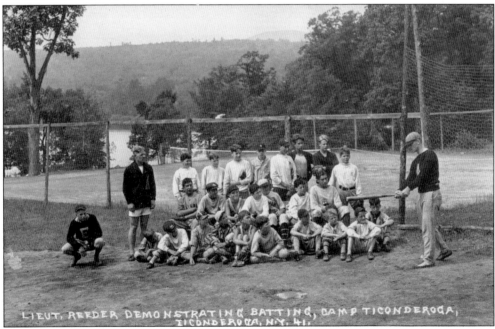

CAMPS. Camps, which are attended by children from the area as well as by those from out of town or state, are very popular in the North. Baseball has always been popular in Ticonderoga, and so the combination of summer, baseball, and camp sounds like fun to many of the kids in the area.

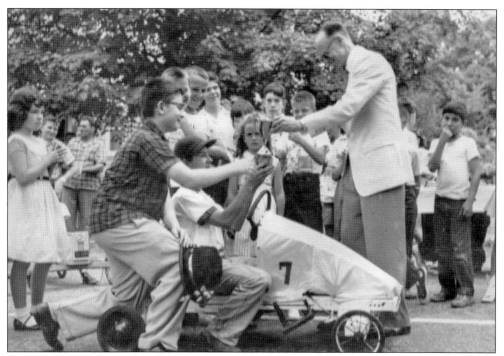

SOAPBOX DERBY. Its soapbox derby time, or at least, it was in was in the 1950s and 1960s. In this picture, Maynard Belden is presenting the trophy.

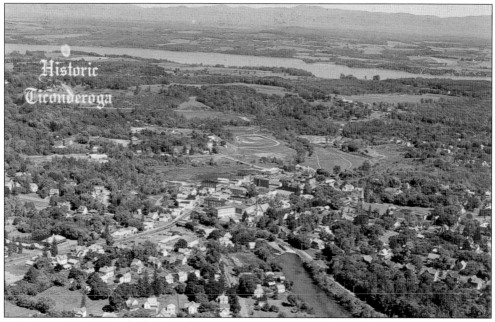

Historic Ticonderoga

OVERVIEW. This picture looks to be from about 1975, as International Paper mill No. 38 is gone, and the resulting park area is landscaped but not completed. Here, one can see the LaChute River at the bottom, pooling behind the D dam. Lake Champlain is near the top, and the Green Mountains of Vermont are at the very top. Just before Lake Champlain near the top right is the fort's peninsula. This picture looks directly east.

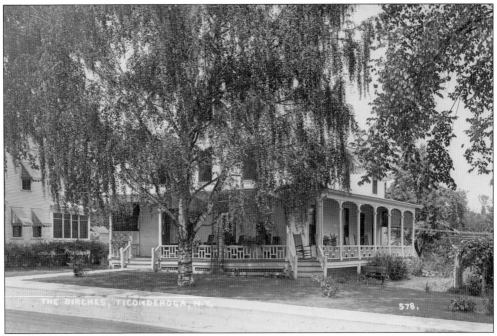

The Birches. Rooming houses abounded in Ticonderoga. This one still exists today on the northwest corner of Wayne Avenue and Montcalm Street and it has been well kept up. When the mill employed about twice as many people as it currently does, rooms were at a premium in Ticonderoga. The "no vacancy" sign was a common sight in town.

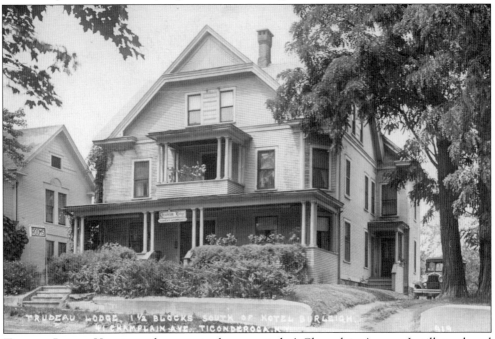

Trudeau Lodge. Here is another rooming house on today's Champlain Avenue. It still stands and still functions as a rooming house. In the 1960s, it was convenient to the then-active downtown and was well maintained.

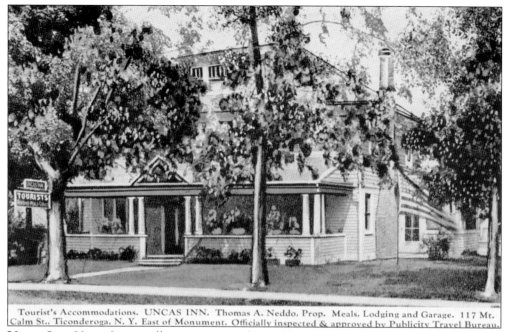

Tourist's Accommodations. UNCAS INN. Thomas A. Neddo. Prop. Meals, Lodging and Garage. 117 Mt. Calm St.. Ticonderoga. N. Y. East of Monument. Officially inspected & approved by Publicity Travel Bureau.

UNCAS INN. Uncas Inn is still in existence today on Upper Montcalm Street, but now business offices are housed there. The Uncas Inn sign still graces the front porch.

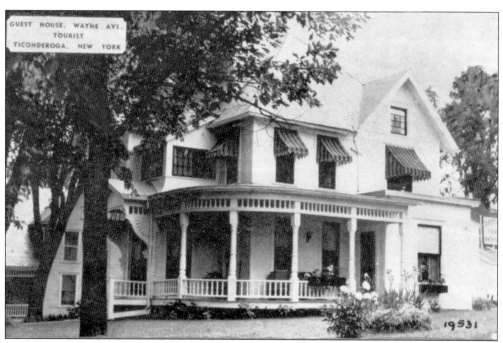

WAYNE AVENUE TOURISTS. This rooming house exists and still operates today on Wayne Avenue.

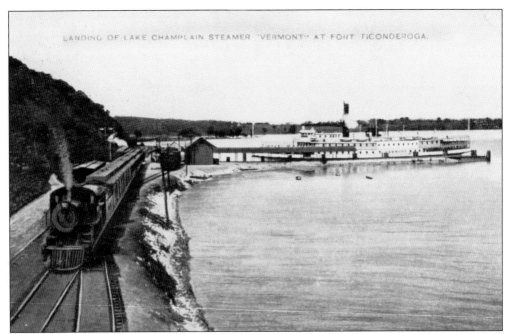

LANDING OF LAKE CHAMPLAIN STEAMER "VERMONT" AT FORT TICONDEROGA.

TRAINS AND BOATS. Here on the shoulder of Mount Defiance, looking north to the fort's peninsula, one can see the southbound train from Montreal and the northbound steamer *Vermont* at Montcalm Landing. Only a tiny stub of the dock is found out in the lake today; in the past, small turtles and frogs could be seen near the dock.

WHITE SWAN. Large Airy Rooms. Restful Porches, Baths. Rates Reasonable. Mrs. Roland Blakely 80 Mt. Calm St., Ticonderoga, N. Y. Officially Inspected and Approved by Publicity Travel Bureau

THE WHITE SWAN. The White Swan is a greenish color now and has recently been renovated. After many years as a rooming house, this building on the southeast corner of Prospect/Wayne Avenue and Exchange/Montcalm Street was acquired by the owners of TiPi, an Italian restaurant, and was renovated. It now sits empty awaiting a new owner.

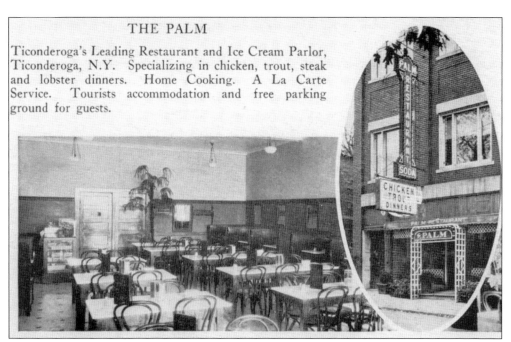

THE PALM

Ticonderoga's Leading Restaurant and Ice Cream Parlor, Ticonderoga, N.Y. Specializing in chicken, trout, steak and lobster dinners. Home Cooking. A La Carte Service. Tourists accommodation and free parking ground for guests.

THE PALM. It bills itself here as Ticonderoga's leading restaurant, ice cream parlor, and tourist accommodations. It stood where Newberry's was later built and where the front of Hacker boats now is on Montcalm Street. There is a picture of a Palm Restaurant at another location; however, it is not know whether or not the same person owned it.

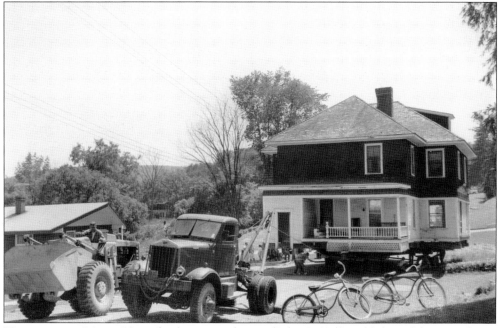

HOUSE ON THE MOVE. Here, the former residence of John B. Tefft, publisher of the *Ticonderoga Sentinel*, and his wife starts its journey to North Wayne Avenue. It is being moved to clear the space for construction of the New Grand Union Building (today's firehouse). (Courtesy of Perry O'Neil.)

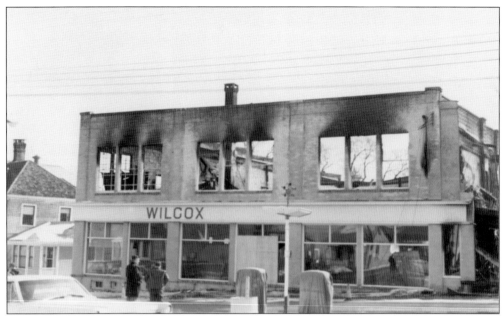

FIRE. Since at least 1875, fire has been the sad end to many old Ticonderoga buildings. The Wilcox and Reagan furniture store, shown here after a devastating fire in 1972, was no exception. It was said by the firemen that this was a hot and difficult fire; happening at night made it even worse. The building was a total loss, and some of that space is a parking lot to this day. (Courtesy of Perry O'Neil.)

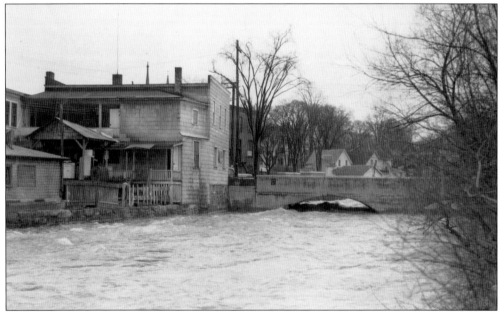

HIGH WATER. With Ticonderoga's business district being on a river, flooding has always been a possibility. In the early days, the big island in the center of town was certainly at some risk, but most of the village area was (and is) somewhat safe. Here is a mid-1970s picture of the Montcalm Street Bridge with LaChute River at full flood. To the left is the back of the onetime village pharmacy. (Courtesy of Perry O'Neil.)

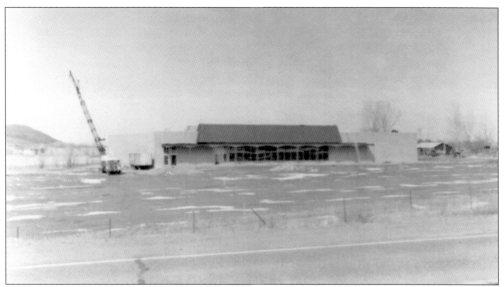

FOUR CORNERS. It may not look like much, but in this picture, one can see the latest evolution in Ticonderoga's town history. Here at what mostly is called the Four Corners is the first building of what became a new town center. Built as a Grand Union store, the building later hosted a Tops supermarket but currently is subdivided into several businesses, including Peebles. Other buildings have cropped up around the Four Corners area. (Courtesy of Perry O'Neil.)

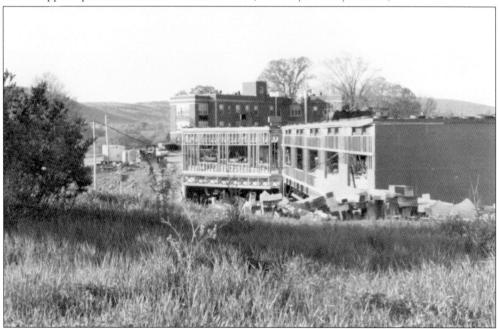

INTER-LAKES. In 1974, the newest Ticonderoga hospital, the Moses-Ludington, now part of Inter-Lakes Health, was constructed at this 40-bed skilled nursing facility. In 2001, the hospital and the nursing facility were renovated to provide today's modern facility. With the taking down of the old hospital in 2012, this facility is all that is left on hospital hill. An assisted living facility is currently being built that will look a bit like the old Moses-Ludington Hospital. (Courtesy of Perry O'Neil.)

Rooms for Tourists. Mrs. Thomas Andrews, 98 West Exchange St., Ticonderoga, N. Y. Opposite Liberty Monument and Historical Building. Telephone 286. Garage. Officially Inspected and Approved by Publicity Bureau.

CIRCLE COURT. Before the Liberty Monument, there was a trough for horses in the center of the road there. On one corner were rooms for rent in the building shown here, established in 1918 by Effie Andrews. The building has evolved over the years into today's Circle Court Motel. The building/barn to the extreme left of this building was replaced by the Ticonderoga Masonic Lodge building.

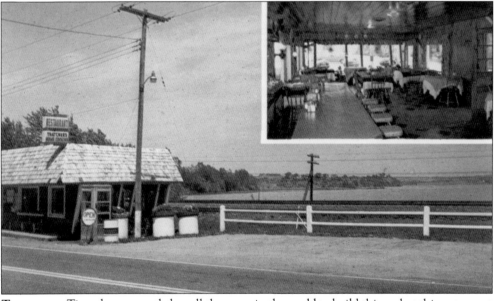

THATCHERS. Ticonderoga mostly has all the room in the world to build things, but this restaurant was built in a very small space between the train tracks and the road. First owned by Frank and Margret Thatcher, the restaurant later changed hands. While the view was great, overlooking Lake Champlain and the fort, and the food and service were superb, parking was somewhat limited, and the building "reacted" to the trains going by in the usual way.

104

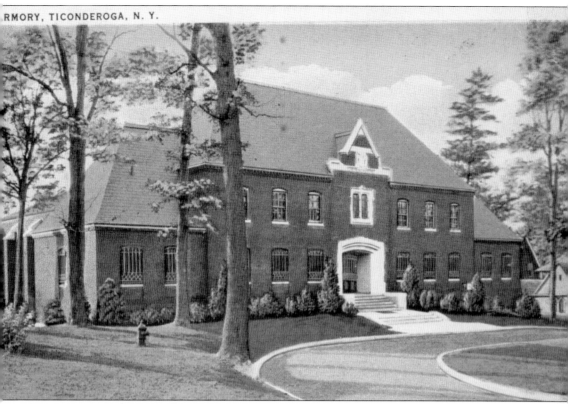

THE ARMORY. The Ticonderoga Armory (1935–2003) was located on Champlain Avenue, Ticonderoga. It was occupied by the following groups in sequential order: the 106th Ambulance Company; F Company; Company C, 187th Field Artillery; and lastly Company C, 105th Infantry. The armory was vacated in 2003, and currently, the town uses the building as a community center.

This is a very good picture of our old fashioned h

THE ROGERS ROCK HOTEL. In 1874, the Rogers Rock Hotel was opened to the public, and in 1903, some of the hotel guests purchased the hotel and opened the "Rogers Rock Club." A windmill was constructed to pump water to the hotel. In 1942, hard times led the club's directors to order the old hotel to be pulled down and the area seeded with grass. With the steamship era over and the world at war, times were changing.

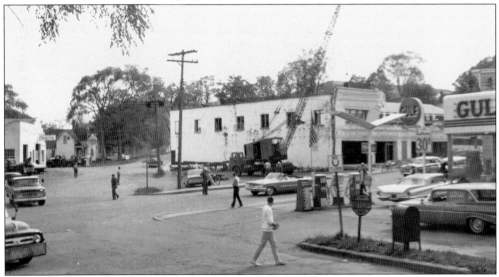

SITE CLEANUP. Where Sharkey's and the Ticonderoga Firehouse are today, a Buick car dealership, an apartment house, and three other houses used to be. The Buick car dealership was first owned by a Huestis and then a Roseman. In another photograph is one of the houses "on the move," but the rest of the structures on this site were torn down. Here, a crane is preparing to remove parts of the old dealership. The intersection shown here is of Montcalm Street, Wiley Street, and Schuyler Street.

Seven

THE BOATS

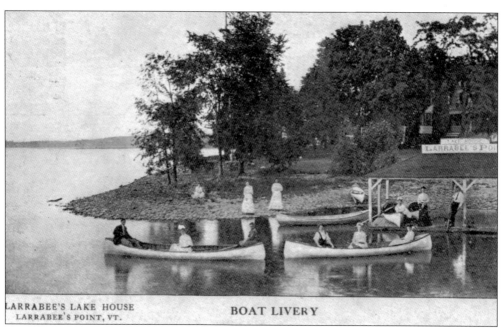

LARRABEE'S LAKE HOUSE
LARRABEE'S POINT, VT.

BOAT LIVERY

BOAT LIVERY. Built about 1847 and seen here after 1890, the Lake House was one of several hotels gracing Larrabee's Point near where today's Fort Ticonderoga Ferry lands. Known more often by its original name, the US Hotel, the building burned in 1917.

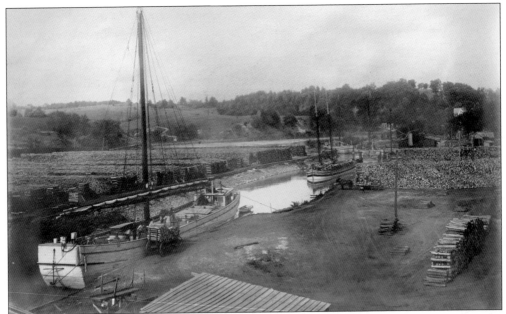

BELOW THE FALLS. Here is the Ti Pulp and Paper wood yard at the lower falls. In those days, the Lower LaChute River was dredged to keep the channel wide and deep enough for boats. These boats had to sail on Lake Champlain after leaving the LaChute River on their way to either the Champlain Barge Canal (opened in 1823) to the south or the Chambly Canal (opened in 1847) to the north. (Courtesy of Ticonderoga Historical Society.)

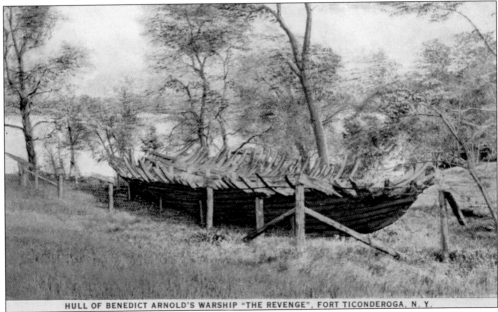

HULL OF BENEDICT ARNOLD'S WARSHIP "THE REVENGE", FORT TICONDEROGA, N. Y.

REVENGE. These remains of a ship are believed to be one of Benedict Arnold's ships, the *Revenge*, near Fort Ticonderoga. This boat was raised from the bottom of Lake Champlain and may or may not have been the *Revenge*. After having fought in the Battle of Valcour Island, the *Revenge* may have escaped to Ticonderoga and been sunk. Supposedly, a chair and a gavel were constructed from the wood after the remaining pieces of the boat were destroyed by weather.

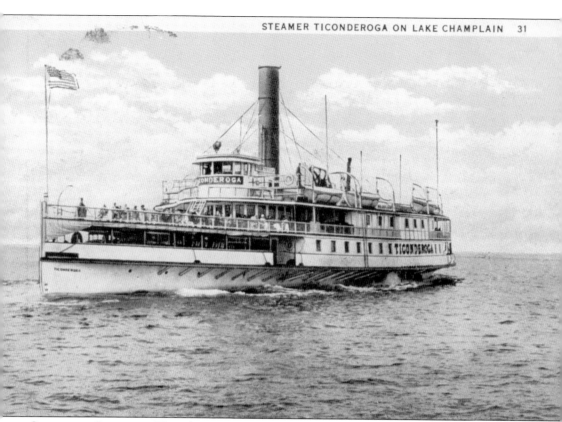

CHAMPLAIN STEAMERS. There has almost always been one or more boats/ships around named *Ticonderoga*. One such steamboat plied the waters of Lake Champlain for many years. In 1954, it was transported back to the town in Vermont where it was built to sit on dry land in the Shelburne Museum, a monument to a bygone but exciting era. Today, visitors can board the boat and experience for themselves a bit of what it must have been like to travel on it. It is said to be the last side-wheel steamer to have operated in America.

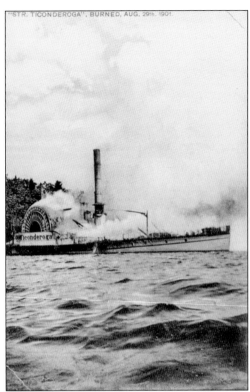

LAKE GEORGE STEAMERS. Here, the steamer *Ticonderoga* is burning on Lake George near the Rogers Rock Club in 1901. This is not to be confused with the Lake Champlain steamer also named *Ticonderoga*. In August 1885 (the year after its launch), this steamer suffered a serious accident and underwent extensive repairs. On the day of this photograph, it had left Baldwin Dock on its daily trip to the south end of the lake when a fire was noticed. The captain steered his boat to the Rogers Rock Hotel's landing, and the crew was safely evacuated. After the fire burned through the landing lines, the boat drifted and sank. To this day, there are pieces of the wreckage on the lake bottom at that spot.

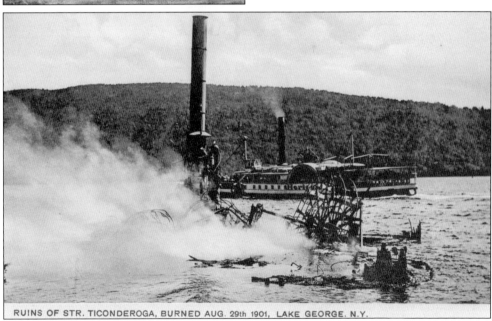

LAKE GEORGE STEAMERS. The *Ticonderoga*, in ruins, is pictured with steamer *Horicon* passing by. *Horicon* is a name said to have been used by the First Peoples for Lake George, and the French called it Lac du St. Sacrement. The smokestack became a sort of monument for the ship and was pointed out by passing boats. There are numerous wrecks on the bottom of Lakes George and Champlain.

CLIMBING THE MOUNTAIN. This photograph will take some explaining. With the steamship era over, the Lake George Steamboat Company needed a new boat. And with the end of World War II, a lot of boats were available. The company acquired an infantry landing craft (LCI) from the Navy and motored it up the Hudson under its own power. It made it through Champlain Canal and onto Lake Champlain. At Montcalm Landing, it was cut into four pieces and transported through the downtown of Ticonderoga to the Homelands on Lake George, where it was put back together with some serious modifications. Christened the MV *Ticonderoga*, it began its new life as a cruise ship. Here is one section of the LCI going up Lake George Avenue, with Lord Howe Lake, C dam millpond, and an old mill boardinghouse called the Beehive in the background.

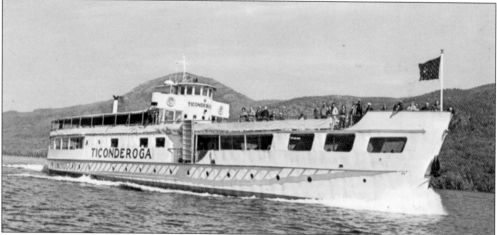

THE FINISHED PRODUCT. No LCI ever looked like this. In 1950, as mentioned above, the Lake George Steamboat Company had purchased an obsolete 270-ton World War II Navy landing craft. The company managed to get it to Ticonderoga and rebuilt and repositioned it on Lake George. The MV *Ticonderoga* plied the waters of Lake George for many years and was still in use in 1976, when it was used to transport vets from the "Big T" (the aircraft carrier *Ticonderoga*) up and down the lake.

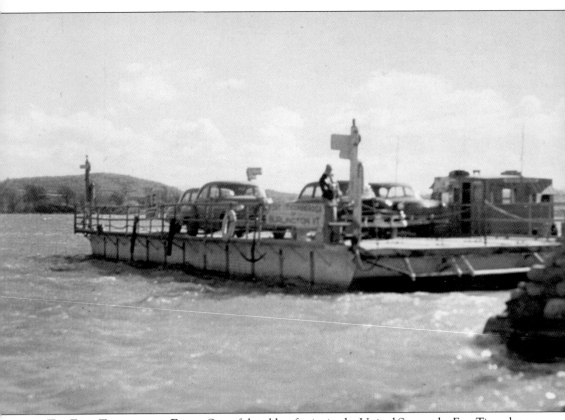

THE FORT TICONDEROGA FERRY. One of the oldest ferries in the United States, the Fort Ticonderoga Ferry was established here in 1759 and has been in almost continuous operation since 1788. Today's Fort Ticonderoga Ferry makes its seven-minute shuttle trips from Larrabee's Point in Vermont to the Fort Ticonderoga landing in New York during the spring, summer, and fall. There has been a ferry here most of the last 250 years. It is nice to know that eagles have returned to Ticonderoga; one of the several things to look for while taking the trip across the lake is an eagle flying overhead. In season, one can buy local apples on board and chat with the crew.

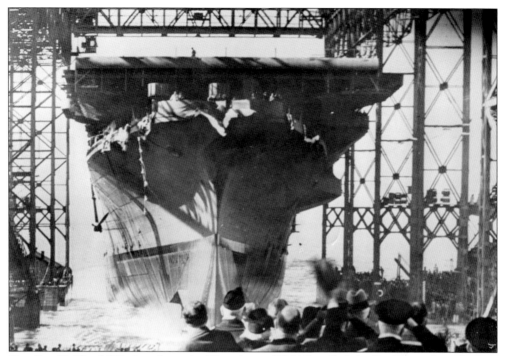

THE BIG T. The USS aircraft carrier *Ticonderoga* (CV-14), called the Big T, was launched on February 7, 1944, in Newport News, Virginia. It was the fourth US ship to bear that name. Stephanie Sarah Pell, of the Pell family that restored Fort Ticonderoga, christened the ship. Here, the aircraft carrier seen being launched in 1944. The ship was decommissioned in 1973 after many years of service, having been refitted and recommissioned to meet different operational demands. Designed as an Essex-class vessel, some consider it the first Ticonderoga-class vessel. In the end, it was sold for scrap in 1974.

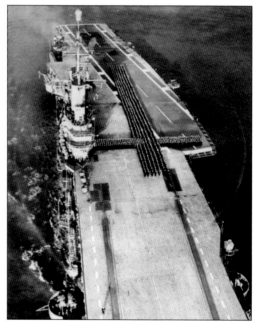

AT SEA. On May 30, 1957, the aircraft carrier *Ticonderoga* is in San Francisco. In this photograph, white-capped sailors form a cross on the flight deck of the USS *Ticonderoga* as the huge carrier passes under the Golden Gate Bridge and into San Francisco Bay on Memorial Day. It was a silent tribute by the personnel of the vessel. As the carrier is too big to pass through the Panama Canal, it made the journey from the East Coast by rounding South America's Cape Horn.

OPPORTUNITY. As the carrier USS *Ticonderoga* sat in the harbor in San Francisco, a crewman returning to the ship snapped this picture of one of the ship's anchor chains.

CHRISTENED. Stephanie Sarah Dechame (née Pell) christened the Carrier USS *Ticonderoga*. One of Stephanie's sons donated a picture of her christening the ship to be used in the book; However, that picture turned out too blurry, but there was another photograph of the event that could suffice. Stephanie met her husband, Roger, at this ship's christening, and their marriage led to her return to Ticonderoga, a place she deeply loved. She was the granddaughter of the principal restorer of Fort Ticonderoga. Hey life was something of a fairy tale, and her death in 2012 was a terrible loss. Ticonderoga's grand dame, she will be missed by many. (Courtesy of Perry O'Neil.)

Eight

THE PEOPLE

HORACE AUGUSTUS MOSES (1863–1947). While Horace Moses's contributions to Ticonderoga cannot be overstated, his contributions to the county, particularly its youth, can also not be overstated. In 1984, the US Post Office put his picture on a stamp commemorating his founding of Junior Achievement. The following is from its Web site: "Junior Achievement (JA) empowers young people to own their economic success." He was one of the almost countless industrialists who created the best of the infrastructure of today's Ticonderoga.

STEPHEN HYATT PELHAM PELL (1874–1950). In 1909, he and his wife, Sarah Gibbs Pell (née Thompson) (1878–1939), began the restoration of Fort Ticonderoga; it was her father who funded much of the early work. Here, Pell stands next to one of Fort Ticonderoga's mortars. Most of the cannons and mortars at Ticonderoga were brought here from other sites, as the Fort Ticonderoga equipment (as well as Fort St. Fredericks to the north) was taken by Henry Knox to Boston to oust the British. The King of England had sent a large flotilla filled with battle-hardened soldiers to the colonies to quell the uprising that started at Lexington and Concord. Sleeping serenely in Boston Harbor, they awoke one morning staring down Ticonderoga's guns. They left quickly. The Revolutionary War had begun in earnest.

THE DOCTORS COMMINS. This painting resides in the Moses-Ludington Hospital. Several pictures were taken at the dedication with various family members. In this shot, Dr. John P.J. "Jack" Commins Jr. (1918–2012) stands beside the portrait of his father, Dr. John P.J. Commins Sr. (1876–1970). Both doctors served their communities long and faithfully. The father started business in Ticonderoga about 1899 and helped found the Moses Hospital in 1908.

ELEANOR MARY MURRAY (1909–C. 1970). Eleanor was a curator of the Fort Ticonderoga Association. She was a graduate of the Ticonderoga High class of 1927, where she said her ambition was to be a teacher at Silver Bay (just down Lake George to the south). Eleanor never married, instead devoting her life to the fort and to her research. She had several publications to her credit, including a booklet, *The Historic Adirondacks*, with Winifred LaRose. For many years, she held various positions at the fort and in the community at large.

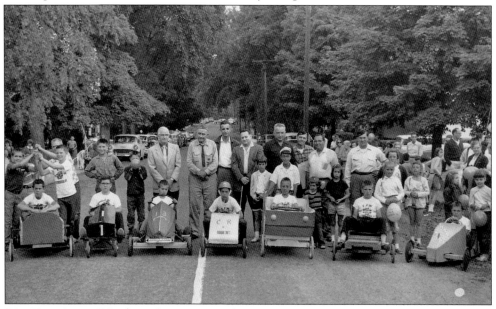

"ON YOUR MARK." In the 1950s, everyone's hopes were high, everyone was ready, proud fathers were in the background, and those who were about to try their luck in vehicles no state would ever license on any of its roads, would release their brakes and take their chances!

Four Generations. In 1862, the older gentleman sitting, Frederick Ellis Provoncha, was born in Blue Ridge, New York, just down the road, but he died here in the Wells nursing home in 1949, a year after this picture was taken. In 1904, the gentleman on the left, Frederick Lawrence Provoncha, was born, also in Blue Ridge. He died in Ticonderoga in 1981. In 1928, in Ticonderoga, the gentleman on the right, Frederick Nicholas Provoncha, was born; he died at his home in Ticonderoga in 1999. This picture was taken in Blue Ridge in 1948 not long after the child, Frederick Vincent Provoncha, was born.

On Cossey Street. Around 1900, Ticonderoga still had several blacksmiths. The gentleman seated here was one of them. Nicholas Frank Denesha (1866–1930) was descended for the soldiers that Louis XIV sent over here in 1665 to pacify the Iroquois. Descended from that fighting stock, he raised his family on a tough side of town during tough times. One of the train lines crossed Cossey Street just below his house, and just up the hill a bit was Mount Defiance. The little girl on the left was Laura Julia Denesha (1906–1955), the author's grandmother.

CLAYTON HARRIS DELANO (1836–1920).
Clayton was born in Ticonderoga, the son of Benjamin Phelps Delano and Amanda Harris. He descends from Phillipe De La Noye of Leyden, Holland, who came over on the *Fortune* to Plymouth in 1621. The spirit of his ancestors, who relied on their own resources to create something out of almost nothing and to leave the world a better place than they found it, is also visible. Teacher, industrialist, benefactor, town supervisor, philanthropist, master of the Masonic lodge, husband, and father— where Horace Moses gave his fortune to Ticonderoga, Clayton Delano gave his life. (Courtesy of the Mount Defiance Lodge.)

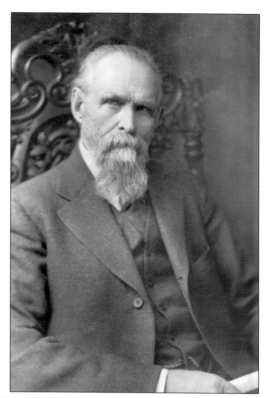

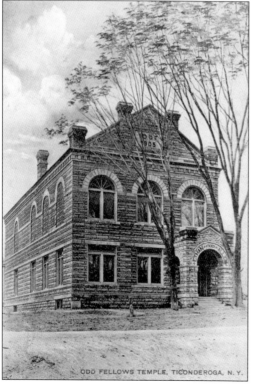

ODDFELLOWS' TEMPLE. The Allen Ethan International Order of Odd Fellows Lodge No. 630 of Ticonderoga, New York, was formed in 1903 and built its temple here in 1905 on Exchange/Montcalm Street. The American branch of the Odd Fellows split from the English branch after the English fellows made significant changes to their charters. Generally speaking, these lodges existed to provide a welfare net that their national governments did not provide. One could acquire something like health insurance from them to pay doctors and hospitals. Following the implementation of the New Deal, membership declined as the government started providing some of those services. In later years, the American Legion bought and still uses the building.

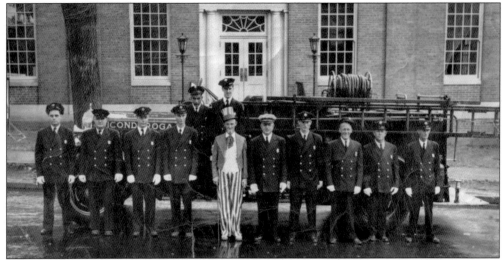

UNCLE SAM. The Defiance Hose Company and the Defiance Hook and Ladder Company were stationed in the downtown, lower village part of town. Not so far away, but in the upper falls area, was stationed the Jeffers Hose. This photograph was likely taken on Fourth of July, the biggest celebrated holiday in Ticonderoga. As this post office was built in 1937, this picture (otherwise undated) was roughly taken in the 1940s. (Courtesy of Perry O'Neil.)

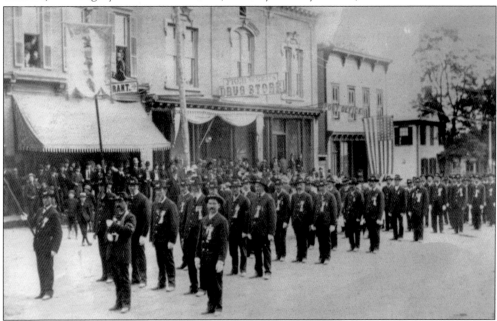

GAR. In this c. 1900 picture, Ticonderoga's aging Civil War veterans (Grand Army of the Republic) parade in front of the Weed block. Clayton H. Delano, president of Ti Pulp and Paper, organized a committee to fund and erect a monument to those who served from Ticonderoga. Ticonderoga's first chapter, No. 65, was chartered on January 19, 1876. Then chapter No. 252 was chartered on April 1, 1902. Capt. Alfred Weed (1826–1868), Company G, 96th New York State Volunteers, joined in November 1861 as captain at age 35 and resigned on June 9, 1862; he then joined the 93rd New York State Volunteers at Plattsburg as a private in Company E on January 22, 1864. He was discharged for disability on February 14, 1865.

THE MASONS. Like many New England–area towns, Ticonderoga has a long Masonic history. In this photograph, Mount Defiance Lodge No. 794 presents Grand Lodge Service awards to its deserving members in 1949. Included in the picture are, from left to right, L.E. McNeal, George Wright, A.B. Drake, Reverend Harmon, Frank Barney, Elmer Spalding, and Fred Flannery. (Courtesy of the Mount Defiance Lodge.)

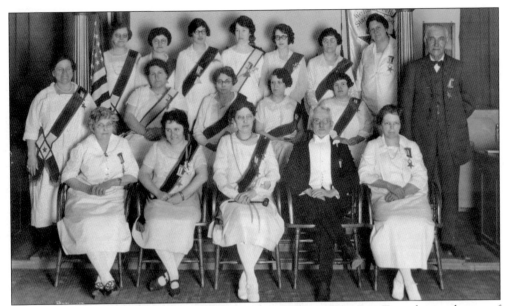

THE EASTERN STAR. Not to be outdone by the men, officers of the Fort Ticonderoga chapter of the Order of the Eastern Star, No. 442, pose for the camera in 1926. The emblem of the order is a five-pointed star with the white ray of the star pointing downwards toward the manger. In the chapter room, the downward-pointing white ray points to the west. The lessons taught in the order are from stories inspired by the Bible. The Masons also sponsor youth groups for young men and women with some additional organizations in New York. (Courtesy of the Mount Defiance Lodge.)

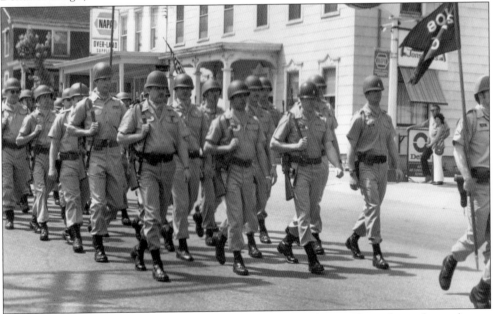

BIG T PARADE. Marching down Montcalm Street in 1976 at the Big T parade are those who put their lives on the line day after day. This parade was an annual event for several years as those who served on the carrier returned to Ticonderoga for a reunion. The town fell in love with the sailors, and they seemed to reciprocate the affection.

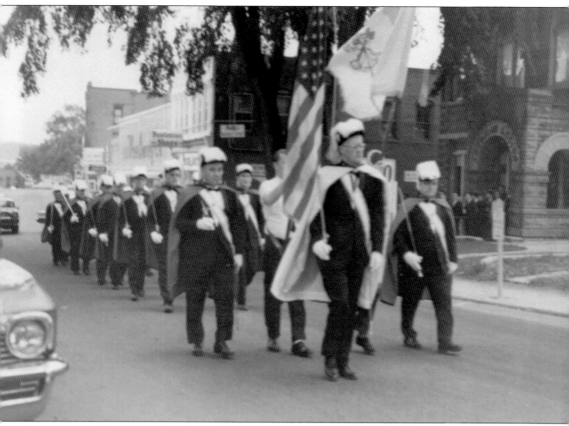

TICONDEROGA KNIGHTS. The Ticonderoga chapter of the Knights of Columbus (Council No. 333) marched up Montcalm Street in the 1960s. Commonly called the KofC, the operation is a Catholic fraternal benefit society. It was founded on March 29, 1882, and exists to offer financial aid to member families. It has served Ticonderoga well and continues that service today. (Courtesy of Perry O'Neil.)

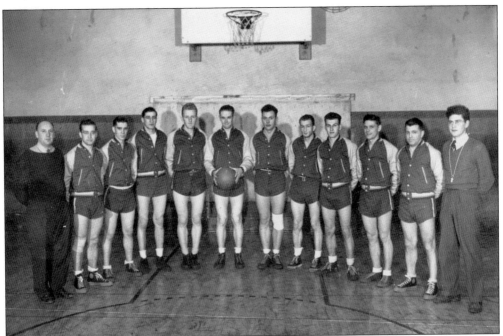

TICONDEROGA CHIEFS. The Ticonderoga Chiefs town basketball team is pictured here. Active in 1946–1948, the Chiefs were serious contenders. From left to right are Olcott, DeFebo, Weatherbee, Morrette, Stanley, White, Baker, Fortino, Marcoux, Streeter, Wendell, and manager Denesha.

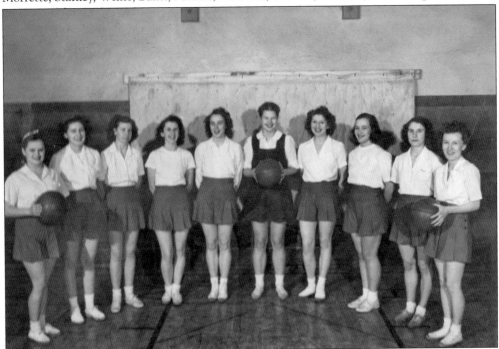

LADIES' BASKETBALL. And here is the Ticonderoga town girls' basketball team in 1946. From left to right are Cobb, Morrette, Moore, Henry, Peasley, Westlund, LaMargue, Hopkins, Zacker, and Flemming.

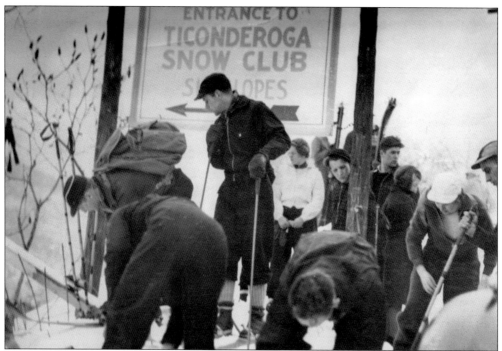

THE SNOW CLUB. Organized in 1936, the club promoted winter sports in Ticonderoga and the surrounding region. National Youth Administration/WPA workers were used to layout trails and improve facilities. The "Punch Bowl" ski and toboggan complex in Lord Howe Valley were created, and things started booming, but a combination of circumstances, influenced mostly by unusually mild winters, eventually doomed the effort, with the Punch Bowl closing during the 1942–1943 season. While it lasted, snow trains made the run to Ticonderoga to take advantage of the facilities. It is said that a few remains of the old lodge building exist along the side of Three Brothers Mountain.

SKIERS. Pictured here are some winter ski enthusiasts who have found their way to Ticonderoga. When the Pilgrims landed in 1620, the world was still embroiled in what is called the Little Ice Age, and snow was a very common commodity. As the world continued to warm, it got scarcer. However, in 1816, "the year there was no summer," winter seemed to be back for good. But after a few years, warming continued again. In the 1950s and 1960s, winters provided all the snow any skier could want.

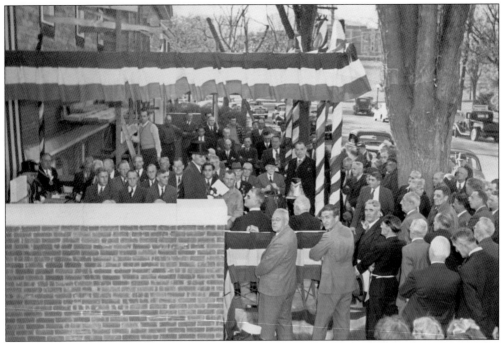

DEDICATING A NEW BUILDING. Here, in 1948, Ticonderoga's Mount Defiance Masonic Lodge No. 794 dedicates its new building on Montcalm Street. After having outgrown its then-current lodging and saved up its pennies, the Ticonderoga Masonic lodge finally broke ground for its new building. (Courtesy of the Mount Defiance Lodge.)

HELPING HANDS. And here in 1980, the Masons visit the local nursing home to help senior citizens. As part of their ongoing outreach to help those in need, the Ticonderoga Masons visited some seniors to try and make their lives a little easier. Many hospitals have benefited from the Masonic Shriners and other Masonic bodies.

PRINCES OF THE ORIENT. The Masons also sponsored a boys' youth organization in the 1960s and 1970s called the DeMolay. Seen here are members around 1975. (Courtesy of the Mount Defiance Lodge.)

TICONDEROGA CUBS. Here Cub Scouts, Troop No. 72, are seen in a parade. There float glides through the center of town during the Big T parade in 1976. The Cubs worked hard on that float, which was a huge space capsule and a helicopter. (Courtesy of Perry O'Neil.)

DISCOVER THOUSANDS OF LOCAL HISTORY BOOKS
FEATURING MILLIONS OF VINTAGE IMAGES

Arcadia Publishing, the leading local history publisher in the United States, is committed to making history accessible and meaningful through publishing books that celebrate and preserve the heritage of America's people and places.

Find more books like this at
www.arcadiapublishing.com

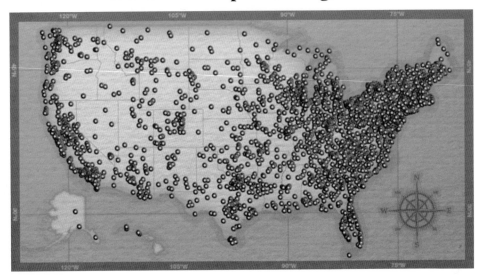

Search for your hometown history, your old stomping grounds, and even your favorite sports team.

Consistent with our mission to preserve history on a local level, this book was printed in South Carolina on American-made paper and manufactured entirely in the United States. Products carrying the accredited Forest Stewardship Council (FSC) label are printed on 100 percent FSC-certified paper.

MADE IN THE